IMAGES
of America

ASSATEAGUE ISLAND

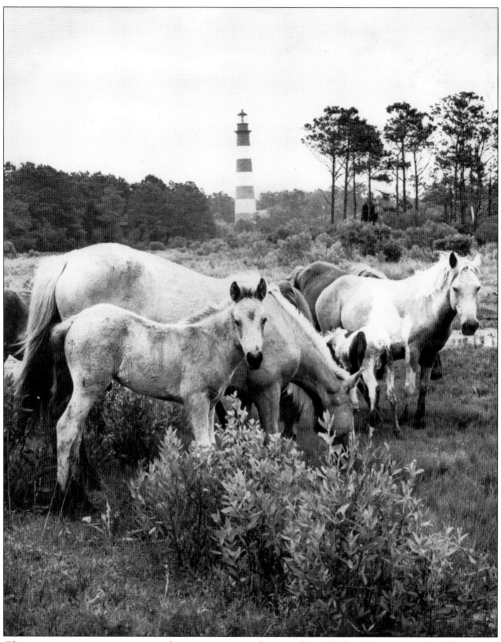

Chincoteague ponies are seen above grazing in the marsh with the Assateague Lighthouse in the background. Both sights attract visitors to the island, but when guests arrive, they find the island has much more to offer. As they say at the shore, "If you get sand in your shoes, you will return." (ESNA.)

ON THE COVER: The tour boat *Kitty* cruised the island while an interpreter spoke about the environs and its history, giving the visitor a chance to see the island from a different perspective and understand its background. At first, fishing was offered but discontinued when they failed to bite. The boat's name was eventually changed to the *Osprey*. (CNWR.)

IMAGES
of America

ASSATEAGUE ISLAND

Myrna J. Cherrix

ARCADIA
PUBLISHING

Published by Arcadia Publishing
Charleston, South Carolina

Printed in the United States of America

Library of Congress Control Number: 2011923257

For all general information, please contact Arcadia Publishing:
Telephone 843-853-2070
Fax 843-853-0044
E-mail sales@arcadiapublishing.com
For customer service and orders:
Toll-Free 1-888-313-2665

Visit us on the Internet at www.arcadiapublishing.com

*To all those with Assateague roots, and to everyone who loves
Assateague and wants to preserve its memories*

CONTENTS

ACKNOWLEDGMENTS

The images in this volume appear courtesy of Connie Sayler Bailey; Myrna Cherrix (MJC); Chincoteague National Wildlife Refuge (CNWR); Duke University; Donald Dunn; Eastern Shore News Archives (ESNA); Lorraine Faith; Nick Greif; Hampton University; Robert Heathcote; Bernice B. Jones; Roy Jones; Vernon Jones; Gretchen Knapp; Ernestine Holston Lutz; Lola Mae McGee; Carlton McGee; Kirk Mariner; the Mariners' Museum; Donna Mason; Linda Wells Miller (Wells); National Archives; National Park Service (NPS); the Old Coast Guard Station, Virginia Beach, Virginia; Matthew O'Neill; Roxane Stevens; George Taylor; Jerry Lou Turlington; the US Coast Guard; William Wells (Wells); Frank Williams; and Robert E Wilson.

A special thanks to those others who encouraged and supported me in so many ways: William L. Cherrix, Sheila Faith, Carrie Feron, T. Maureen Toy, and Janet Wells.

Introduction

Assateague Island is the only uninhabited barrier island off the shore of the Delmarva Peninsula in Virginia that is easily accessible by humans. It is owned and managed by two agencies of the Department of the Interior: the US Fish and Wildlife Service and the National Park Service.

Its long history begins with its creation as an island from the buildup of sediment from the ocean floor created by the action of wind, waves, tides, currents, and storms. These forces of nature cause barrier islands to grow and shrink by the opening and closing of inlets, forming a chain of islands or combining to form a much larger land mass. During its history, Assateague has been an island, as it is today, as well as part of a peninsula. A hurricane in 1933 established the northern boundary of Assateague by creating an inlet at Ocean City, Maryland. Through dredging and the building of jetties, the Army Corps of Engineers has kept this inlet open. This has altered the profile of Assateague Island, shifting the northern section almost half of a mile west.

Native Americans first came to this area to enjoy the plentiful hunting and fishing grounds. They gave it the name "Assateague," interpreted as meaning "a running stream between or swiftly moving water." The Assateague Indians were friendly at first, but the encroachment of the British on their land and the desire of Colonel Scarbourgh to eliminate them from the area brought about their retreat to Maryland.

In 1687, Capt. Daniel Jenifer and his wife, Anne Toft, were granted a patent for 3,500 acres, the entire portion of Assateague Island below the division line with Maryland. Patents were granted to persons who supplied transportation for newcomers to the colony. According to law, a minimum of four men needed to live on the land and attend to stock to secure the patent. Most of these immigrants were indentured servants, but some were prisoners. Who came to Assateague is undocumented.

Captain Jenifer sold the entire patent to Maxmillian Gore in 1689 for 12,400 pounds of tobacco. Gore's will, probated in 1696, left the entire patent to his son Daniel and his stepsons John, James, and Thomas Smith. Thomas Teakle Gore, Daniel's grandson, inherited all the land south of Kerr's Marsh in 1770. About 25 people were living on Assateague at that time. Thomas T. Gore sold two parcels of land to Daniel Mifflin in 1794. One of these parcels was 163 acres across from Piney Island, which Mifflin shared with three other men: John Lewis, Arthur Cherrix, and Levin Hickman. In 1818, Lewis, who operated a saltworks, bought out the other owners. This parcel became the area later known as Assateague Village.

During the American Revolution, Assateague and Chincoteague Inlets performed a key role. The British blockade sealed off all the major ports, keeping necessary supplies from reaching the colonies and the colonial army. Merchants discovered that they could smuggle supplies through the blockade by means of Chincoteague Inlet. Their goods would be transported overland to Snow Hill, Maryland, loaded on to ships, and sailed down the Pocomoke River to the Chesapeake. The significance of this was such that the Continental Congress provided protection for these merchants.

The coast adjacent to Assateague Island became the main highway for the shipping of goods between the colonies. Shoals or sandbars extend as far out as 12 miles off the coast, creating hazardous conditions for merchant ships. At the time, there was no lighthouse between Cape Helopen, Delaware, and Cape Charles, Virginia, a distance of over 100 miles. Sailors petitioned the government to improve the situation. Finally, in 1832, Congress appropriated money for a lighthouse to be built in the area of Assateague. The US government purchased 50 acres of land adjacent to the land of John Lewis from the heirs of Thomas T. Gore's daughter. A 45-foot-tall lighthouse was constructed on a 22-foot-high dune and put into service in early 1833. From the beginning, this light proved to be inadequate. The lighthouse was too short, and the power of the light was too weak to be effective. Visible only 14 miles out to sea, by the time sailors saw the light, it was already too late.

By the 1830s, interest in the harvesting of seafood as an industry began to take hold. The population of the Assateague grew. Many of the new inhabitants were watermen from Sussex County, Delaware, and Worcester County, Maryland, who moved south to reach the ocean when inlets closed.

Problems with lighthouses continued to grow, partially due to the fact that Stephen Pleasonton, the person in charge, had no engineering or maritime experience. In 1850, the government established a Lighthouse Board consisting of engineers and military personnel to review the situation and manage the future building and operation of lighthouses. A survey conducted in 1852 found that Assateague needed to be upgraded to a first-order lens with a focal plane of at least 150 feet above sea level. In 1857, as a temporary improvement, it was fitted with a third-order Fresnel lens. Money was appropriated, plans were drawn, and preliminary work began in 1860. However, the onset of the Civil War ceased all activity.

The confederacy passed a law to confiscate all private land held by federal employees. Lighthouse keeper David Tarr, a landowner on Chincoteague, asked to be relieved of his position to protect his property. Residents of Assateague and Chincoteague were asked to pledge their loyalty. All but two persons chose to remain with the Union. The fact that they were tied economically to markets in the North and had family ties with the North influenced their decision. Company A, 1st Regiment Loyal Eastern Shore Volunteers was formed with about 45 members from the area.

Construction of the new lighthouse resumed in 1866 and was completed in October 1867 with two keepers assigned to the light.

With the creation of the US Life-Saving Service to assist ships in distress and rescue victims, four stations were established on Assateague Island, including Assateague Beach and Pope Island. The US Life-Saving Service merged with the Revenue Marine Service in 1915 to form the US Coast Guard (USCG). A new Coast Guard station was built in 1922 near the end of the newly formed "hook."

Unregulated fishing and hunting caused a depletion of resources. The changing shape of the island and the silting in of Toms Cove made access to the fish factories impossible for large ships. In 1922, a modern era was emerging on Chincoteague with a new bridge to the mainland, cars, trucks for shipping, telephones, electricity, movies, churches of many denominations, and a new school. Automation of the lighthouse took away the final lifeline to the world. The village was no more.

The federal government recognized the future importance of Assateague Island, located in the Atlantic Flyway, as a refuge for waterfowl. In 1943, with monies collected from the Federal Duck Stamp, the US Fish and Wildlife Service purchased most of Assateague Island for $75,000 and began federal administration of the island.

One

BEACONS ON THE WATER

The population on Assateague was slow to grow. The first hundred years only saw an increase from the four men required to settle the patent to the estimated 25 residents at the time of the American Revolution.

The lighthouse, built in 1833 under the direction of Stephen Pleasonton, the fifth auditor of the treasury and superintendent of US lighthouses, and Winslow Lewis, a retired sea captain, was lacking from the beginning. With Pleasonton's frugal management and Lewis's lack of engineering skills, most of the lighthouses built during their era (1820–1852) were, at best, inadequate.

David Watson, a native of the Eastern Shore, was appointed the first lighthouse keeper. Along with his wife and several of his children, he moved into the keeper's house and became part of the community. He bought property, and his children married into local families as the area began to grow.

Plans for a new lighthouse were drawn. However, the Civil War halted its construction. Although located in the Commonwealth of Virginia, Assateague and Chincoteague Islands remained with the Union. Rebel sympathizers stole the lighthouse lantern. It was soon recovered, and Union troops were assigned to provide protection for the lighthouse.

After the war, construction resumed and the new lighthouse and a duplex keepers' dwelling were completed in September 1867. Both structures were located on the sites of the former tower and keeper's house. The 142-foot-tall lighthouse with the first-order Fresnel lens now required two keepers.

As Assateague Island grew in size and the shipping increased along the coast, additional manpower and aids to navigate were needed. The lightship *Winter Quarter* at the Maryland border, Fishing Point Lighthouse at the southern end of Assateague, and channel markers were all installed.

In 2004, the USCG conveyed ownership of the Assateague Lighthouse to the Chincoteague National Wildlife Refuge but retained ownership of the light as a major active aid to navigation. A thorough inspection and evaluation of the tower was conducted and found it needed major restoration. The Chincoteague Natural History Association has undertaken raising funds and is overseeing the restoration.

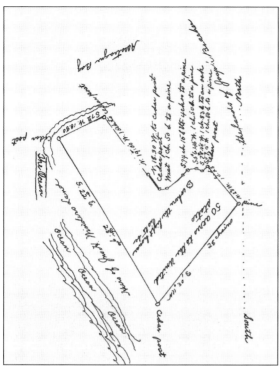

On May 4, 1832, the federal government purchased 50 acres of land for a lighthouse at the southern tip of Assateague Island from the heirs of Comfort Gore Winder. This purchase confirmed that there was significant traffic using the maritime route along the shore as well as the hazards of navigating the Chincoteague Inlet. (CNWR.)

This 1852 map of the southern end of Assateague shows how close the lighthouse was to the ocean when it was built. Toms Cove and the area of beach known as the "hook" did not exist. It was said that while the lighthouse was being built, the workers could listen to the sound of the surf. (NPS.)

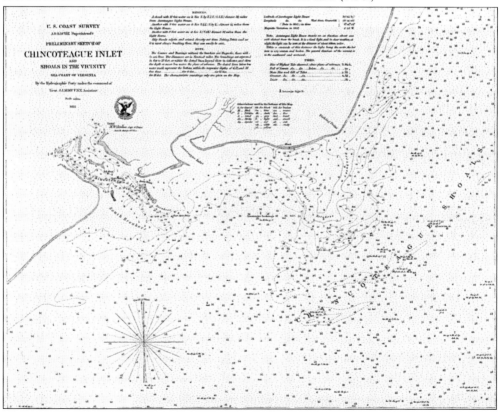

The first Assateague Lighthouse was constructed using plans of the generic lighthouse developed by Pleasonton and Lewis. It stood 45 feet tall on a dune, one mile from the water on the south and one and a quarter miles from the Atlantic Ocean on the east. The structure, made of whitewashed brick, was 22 feet in diameter at the base. (Matt O'Neill.)

The lighting for the 1833 lighthouse was a chandelier type arrangement featuring 11 burners fixed with 14-inch metallic reflectors and a modified Argand-style lamp developed by Winslow Lewis. The design drafted poorly, causing the lamps to soot up quickly, which required constant cleaning and adjustment. In good weather, the whitish light was visible a distance of 12 miles. (Matt O'Neill.)

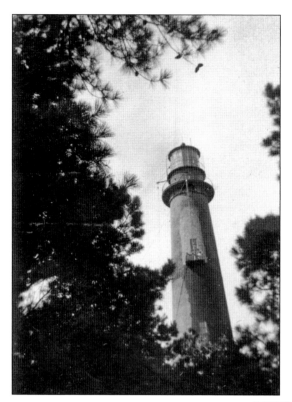

At the end of the Civil War, construction on the lighthouse and a keeper's dwelling was resumed. On October 1, 1867, the beacon was lit and shown for the first time, yet only the tower was built at that time. Sperm or lard oil was used for fuel and could be stored in the tower. (Wells.)

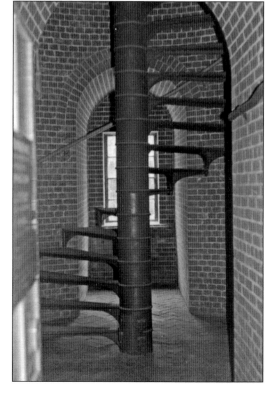

The circular cast iron stairway leading up the tower is made of individual steps fitted around a center column. There are 175 steps with six landings, and each section contains 25 steps. The stairway is contained in a brick cylindrical inner column. Wooden steps lead to the workroom and lantern. (Wells.)

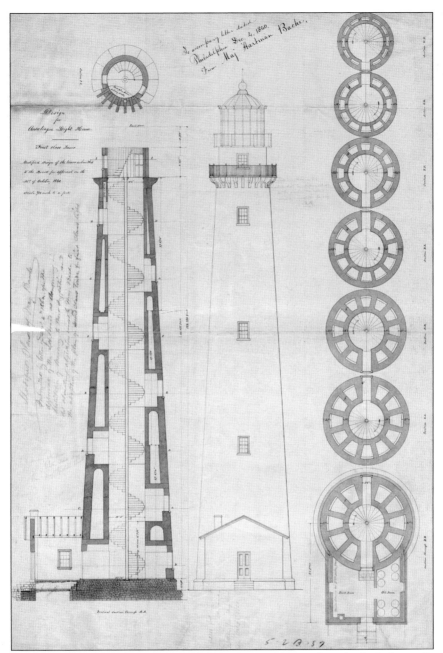

The original plans for the Assateague Lighthouse were submitted to the Lighthouse Board in 1860. In 1861, work started on the new lighthouse by building a wharf and access road to haul supplies to the site. Construction was abruptly ended and all funding withdrawn in the spring of 1861 due to the onset of the Civil War. The original allotment granted by Congress was $50,000. After the war, an additional $25,000 was needed. The plans called for a conical brick tower with a cylindrical inner tower. The inner tower was designed with openings to provide for the optimum draft for the lantern. A vent in the roof allowed smoke and gases to escape. The entrance to the lighthouse was through a vestibule containing two rooms—one room served as a workroom and the other as a storage room for fuel. The oil shed was built at a later date. (NARA.)

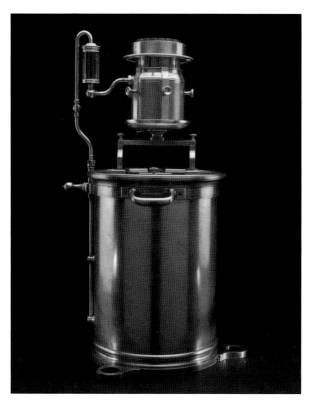

This five-wick oil lamp used in first-order lighthouses like Assateague is made of brass, steel, and glass. It produced a much cleaner flame than the Argand-style lamps. Along with other duties, it was the responsibility of the keepers to keep the brass on the lantern shining. (The Mariners' Museum, Newport News, Virginia.)

In 1892, while other construction and renovations were going on at the lighthouse, a new iron hatch door was installed in the workroom of the tower leading to the lower gallery. This door provided weather-tight access to the gallery. It is the same type of door found on a ship. (MJC.)

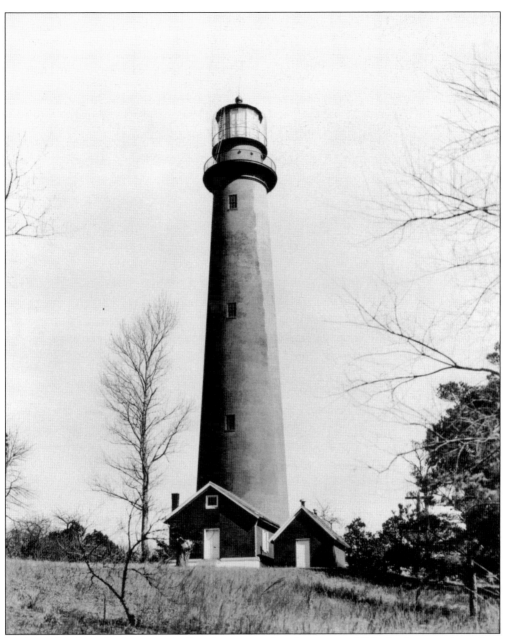

Looking closely at the lantern, the lens is not seen, but drapes are visible. In the morning, when the lens was being cleaned, drapes were hung around the lantern to keep the sun's rays out. The purpose was to keep the glare of the sun from reflecting off the prisms of the lens, which would affect the visibility of the keeper, and to prevent the lantern room from becoming overheated. Upon closer look, one can see that there is a screening surrounding the lantern. This was put in place to keep flocks of waterfowl from crashing into lantern, breaking the glass, and dying. Due to the rising cost of lard oil, the Lighthouse Board decided to switch to using cheaper kerosene. However, because of its flammability, kerosene could not be safely stored in the lighthouse. The oil shed, to the right of the tower, was built for this purpose in 1892. (The Mariners' Museum, Newport News, Virginia.)

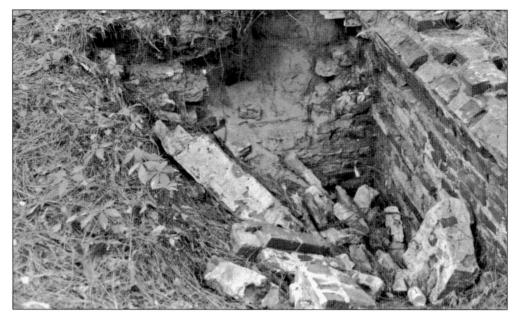

Several vaults or caves made of cement and topped with brick were found in the hill around the lighthouse. They are believed to be storage areas for oil before the use of kerosene, though others think that they may have been root cellars. For the safety of visitors, they have been filled in. (Wells.)

The generator room was located in the entryway of Assateague Lighthouse. In 1933, the Assateague Lighthouse's light source was changed to a 1,000-watt bulb fueled by battery power. Generators set on concrete platforms were located at the base of the lighthouse. To keep the light working properly, the batteries had to be charged for 15 hours a week. The Killick Shoal keeper performed this task. (CNWR.)

16

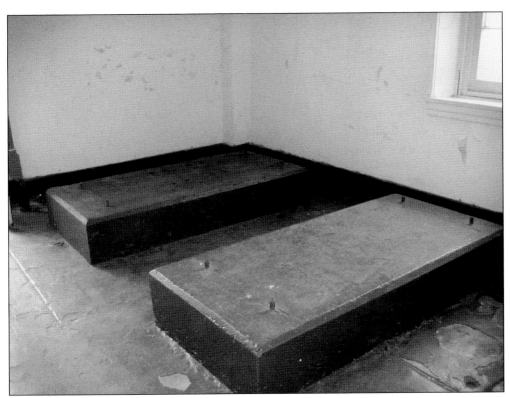

These concrete slabs were installed in the entranceway of the lighthouse to support the generators. When the lighthouse was provided with commercial electric power, the generators were removed, leaving the slabs behind. A raised floor has been installed over them to provide a reception area and gift shop for visitors to the lighthouse. (MJC.)

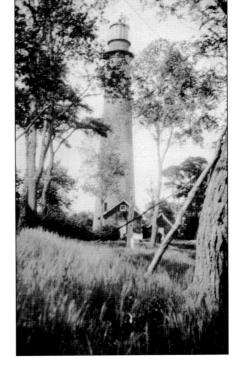

The lighthouse became the responsibility of the Coast Guard in 1939, when the US Lighthouse Service was absorbed by the Coast Guard. In March 1942, Norman Jones relieved Demorest Peterson, taking over responsibility for charging the batteries. The oil shed featured two bunks and a three-burner coal stove. (Wells.)

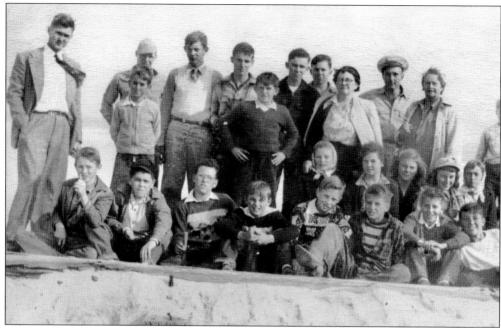

In 1949, Lillian Rew took her class to Assateague to visit the sites featured in the newly published book *Misty of Chincoteague*. The class traveled to the island by boat and was met by Capt. Edward B. Lewis of the Coast Guard, who provided transportation to the Coast Guard station and the lighthouse. (Lillian Rew.)

In the photograph above, Lillian Rew's class is standing in front of the lighthouse. Others accompanying the class were Chincoteague principal William C. Carey, county school supervisors Avery Lewis and Blanche Joynes, and Chincoteague town historian Victoria Pruitt. Notice that the brick walkway from the keeper's house to the tower was still in place. (Lillian Rew.)

When battery power was installed to automate the lighthouse, the need for keepers no longer existed. The surplus property was offered to different agencies of the government, but there were no interested parties. It was decided to sell off the excess property. The Coast Guard only kept a 100-by-100-foot lot surrounding the lighthouse and oil shed. (CNWR.)

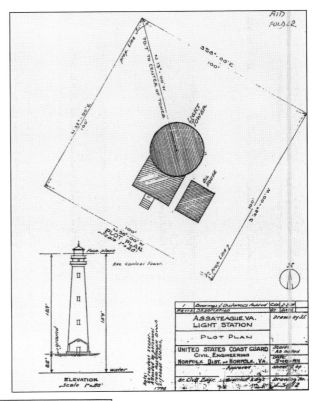

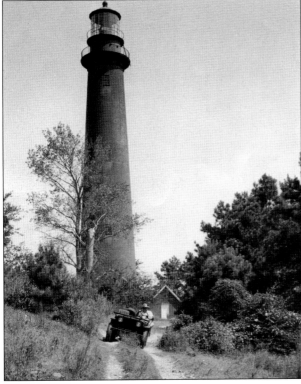

Refuge manager Jake Valentine drives a Jeep near the lighthouse before any changes in the area were made. The rutted road was reconfigured and paved after the bridge to Assateague was built. The Coast Guard still serviced the light and provided personnel to charge the batteries and change bulbs. (CNWR.)

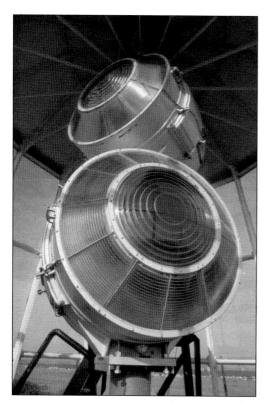

The Directional Code Beacons (DCB), which replaced the battery-operated lantern in 1961, greatly increased the intensity of the light. It now emits 1.8 million candlepower and is visible up to 22 miles in good weather. Commercial electric power eliminated the need for the batteries and generators. The rotating beacons, set at an 11-degree angle atop one another, produce a double flash every five seconds. (Robert E. Wilson.)

In 1968, the USCG painted the lighthouse red and white. These colors represent its day marker, or daymark, which is how it is recognized by ships at sea. Each lighthouse has a different daymark or color pattern. For the locals, it was a drastic change. To this day, if they see a picture of the lighthouse with the red cement wash, they say, "Now, that's the lighthouse I remember." (CNWR.)

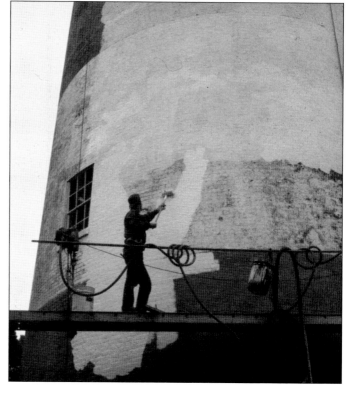

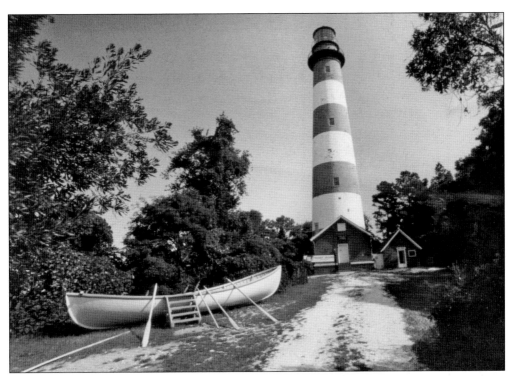

After the bridge was built and visitors began coming to the island for recreation, the CNWR constructed a parking lot as well as a trail through the woods to provide access to the lighthouse. Entrance inside the lighthouse was not yet permitted. Along with the Fresnel lens on display in the vicinity of the lighthouse, a surf rescue boat was placed nearby as an artifact of the island's history. (CNWR.)

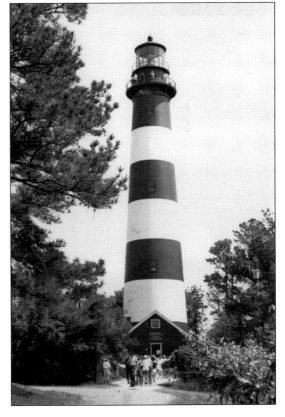

Before the Coast Guard conveyed ownership of the lighthouse to the Chincoteague National Wildlife Refuge (CNWR), they opened the lighthouse to visitors on holiday weekends during the summer. People waited in long lines for the opportunity to climb the lighthouse, view the lens, and observe the island from the above. (ESNA.)

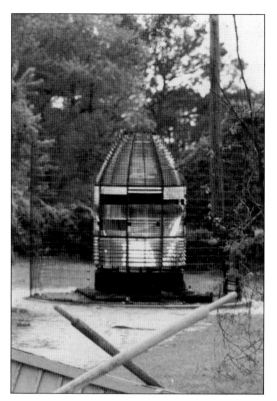

In 1961, the first-order Fresnel lens was removed from the Assateague Lighthouse, packed away, and stored in the basement of the Eastern Shore of Virginia Historical Society at Ker Place, Onancock, Virginia. Locals wanted it back at the site, and in 1972, it was returned and displayed outside the lighthouse. It was surrounded by turkey wire where it became a victim of the elements and minor vandalism. (MJC.)

While under the auspices of the USCG, the following notice was posted on the door. "WARNING—All persons are warned not to trespass on this property or to injure or disturb any property of the U.S. Coast Guard. All violators will be prosecuted." Another sign to the right of the door indicated that the lighthouse was a fallout shelter area. (Kirk Mariner.)

The Oyster and Maritime Museum was opened in April 1972 by a group of local women who wanted to preserve the history, oyster trade, and seafood business of the island. A display of tools for the harvesting of oysters and how they were prepared for market as well as shells, historical photographs, models, and examples of native wildlife were on display for the visitor. (MJC.)

What to do with the 1867 first-order Fresnel lens? It sat outside the lighthouse unprotected from the elements and vandals. The Oyster and Maritime Museum, located just before the bridge to Assateague Island, was given permanent ownership of the lens. They obtained a loan for an addition to their building to provide exhibition space in the front window for the lens. (Lorraine Faith.)

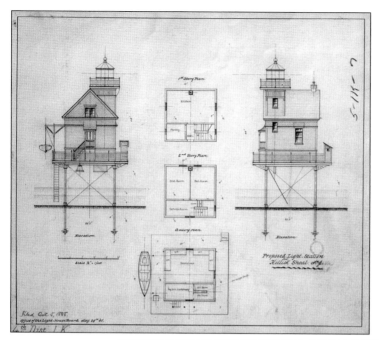

Killick Shoal Lighthouse was a one-and-a-half-story frame building constructed on pilings in 1886. Located in Chincoteague Channel, its fourth-order fixed white light guided boats away from the dangerous shoals in the channel. It was painted white with a red roof. A fog signal, located on the lower level, operated during bad weather. It was one of the two lights that supplemented the Assateague Light. (NARA.)

Keeper William Major Parker and his wife, Venus, lived at and took care of the Killick Shoal Lighthouse for 26 years. People recall "Aunt" Venus offering her friendly wave to ferry passengers. Parker died alone at the lighthouse while his wife was ashore. She took over management of the lighthouse until a new keeper was appointed. (Wells.)

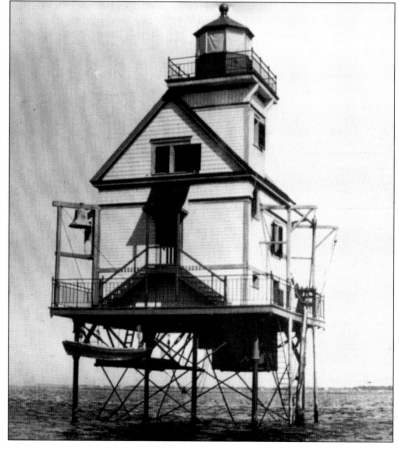

A view of the Killick Shoal Lighthouse was taken from the ferry that ran between downtown Chincoteague and Franklin City, Virginia, where the railway terminal was located. The lighthouse was about 3.5 miles south of Franklin City. The railroad provided passenger service and was the main shipping point for seafood before the causeway to the mainland was built in 1922. Killick Shoal Lighthouse was dismantled in 1935. Only the pilings remain. (Wells.)

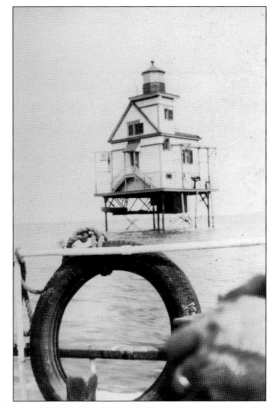

The Assateague Lighthouse was 137 years old when the Chincoteague National Wildlife Refuge accepted ownership. Routine maintenance was done regularly but no major repairs had been performed in years. An assessment of the structure revealed the need for significant restoration. Structures were installed for the safety of visitors during completion of the refabrication of the lower gallery. (MJC.)

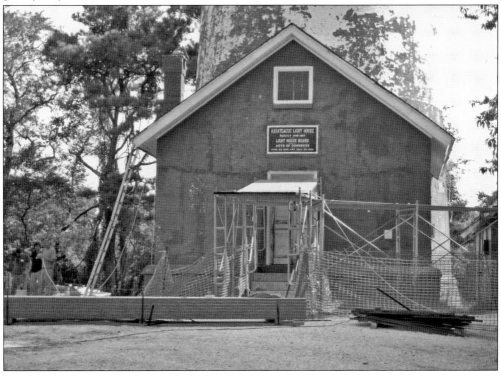

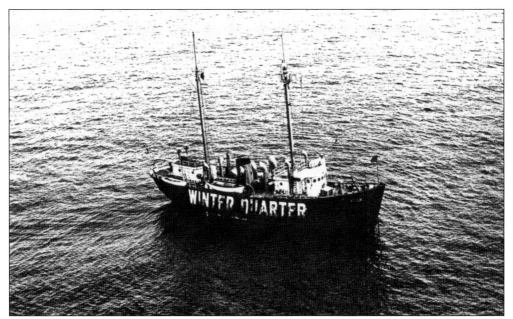

The lightship *Winter Quarter* was put into service in 1874 to supplement the Assateague Lighthouse. The increased coastal commerce and continued shipwrecks created a need for better identification. It was located about 8.5 miles off Assateague Island, 13 miles from the Assateague Lighthouse, near the Maryland-Virginia border. Lightships were located in areas where lighthouses could not be placed. (Roy Jones.)

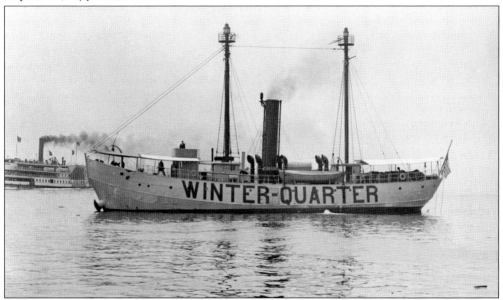

Lightships were identified by number and received the name of the station they served. When they were moved from one station to another, they retained their number but changed their name. Several different lightships served at Winter Quarter Shoal lightship station. When a lightship needed repairs or servicing, a substitute lightship named *Relief* would take its place. *Winter Quarter* was removed in 1961 when the DCB beacons were installed in the Assateague Lighthouse. (USCG.)

Two

GUARDIANS OF THE LIGHT

Early keeper appointments were usually political and altered with the change of administrations. When the Lighthouse Board was established, manuals of instructions were created to guide keepers and help improve efficiency. Keeper appointments were restricted to persons between the ages of 18 and 50 years old who could read, write, and keep accounts. They needed to be able to pull and sail a boat and be able to make minor repairs. Experience at sea, familiarity with and being able to discern different weather conditions, and the ability to withstand inclement weather were favorable qualifications.

Besides their duty monitoring the light nightly in the watch room, keepers had to prepare the light in the morning for the following evening. They cleaned the lens, trimmed the wicks, and refueled the lamps. At night, they divided their shifts, making sure the lamp remained lit, charted the weather, watched for ships at sea, and monitored other area aids to navigation.

The Assateague Reservation, as the keepers called it, was 50 acres, so they had plenty of room to raise chickens, hogs, and sheep as well as plant and tend to a vegetable garden, providing food for their table. They also cut trees from a wood lot to supply fuel for their fireplaces and carried out minor repairs and painting around the light station. Periodic inspections were made by district inspectors to ensure that all was in order.

Certain restrictions were placed upon the keepers. They were to be alcohol-free and were not permitted to take in boarders. Keepers could not engage in any business that would interfere with their attending to the duties or presence at the station.

Beginning in 1863, keepers were issued uniforms consisting of a dark blue coat, trousers, and vest. While they were performing duties inside the lighthouse, they had a white linen regulation apron. A brown working suit was provided for outside labor.

When the 1867 lighthouse was built, the average annual salary for a lighthouse keeper was $600 a year, paid quarterly. Assistant keepers were paid a lesser amount.

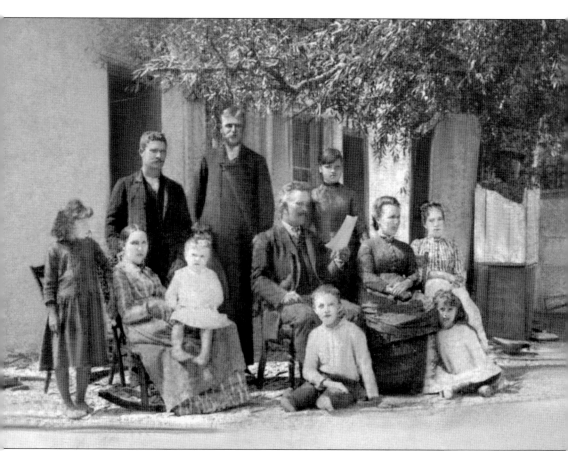

In 1873, John Anderton received a temporary appointment as principal keeper. He was criticized in the press for only being 24 years old, unmarried, and generally unfamiliar with lighthouses. He received his permanent appointment in 1876 and retired after 45 years of service in 1918. Anderton represented the Department of Works at the Pan-American Exposition in Buffalo, New York, and was there when President McKinley was assassinated. He also represented the Lighthouse Service in Jamestown, Virginia, in 1907 for the tercentennial. Under his leadership, the Assateague station was noted for its excellent records and inspections. Anderton was a leader in the community, both within Assateague and Chincoteague. This 1888 picture offers a view of the keepers and their families outside the duplex keepers' dwelling built in 1867. From left to right, they are (first row, seated on floor) John Anderton Jr. and Bessie Anderton; (second row) Jane Quillen, Libbie Quillen, Hilary Quillen, Minnie Quillen (hidden), John Anderton (principal keeper), Clara Anderton, and unidentified; (third row) Samuel Quillen (first assistant), Winred Hopkins (second assistant), and Ida Virginia Taylor (Hopkins's future wife). (Jones family.)

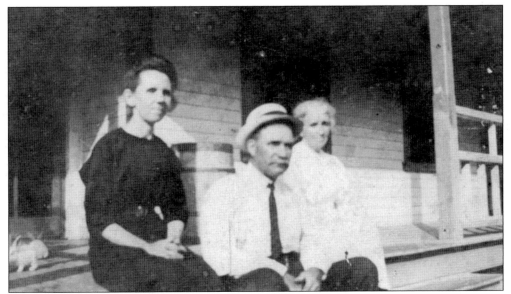

Ida Watson Jones, first assistant keeper Samuel Quillen, and his wife, Libbie, relax on the steps of the keepers' dwelling. Some rabbits are running loose on the porch behind them. This photograph was most likely taken on a Sunday or a holiday as they appear to be wearing dress clothes and Quillen is not in uniform. (Quillen.)

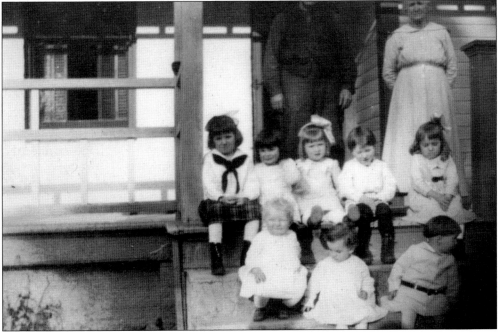

Keeper Samuel Quillen and his wife, Libbie (in rear), pose with some of their grandchildren on the steps of the keepers' dwelling in the early 1920s. Quillen retired in 1922 after serving as principal keeper of the Assateague Lighthouse for two years and as first assistant keeper for 39 years. Seated from left to right are (first row) Ralph Jones, James Quillen, and George Milton Clear; (second row) Hilda Quillen, Edward Quillen, Ruth Jones, Allen Quillen, and Melvina Clear. (Jones family.)

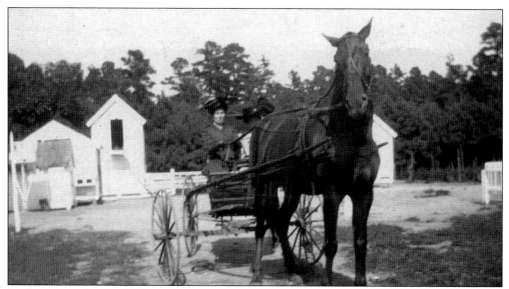

In the image above, Edith Quillen and an unidentified woman enjoy a carriage ride with her father's horse. The keepers kept their personal pets and animals as well as those used to carry out lighthouse duties. They usually rode on horseback to visit the Life-Saving Station or to check and service the lights on Fishing Point. (Quillen.)

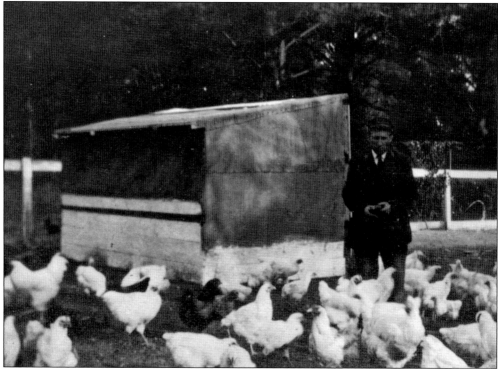

Keepers were allowed and encouraged to grow or raise their own food whenever possible. Keeper Collins is seen here in the chicken yard. A number of chickens were kept for their eggs as well as their meat. Each of the four keepers had three or more children, requiring a large amount of food. (Wells.)

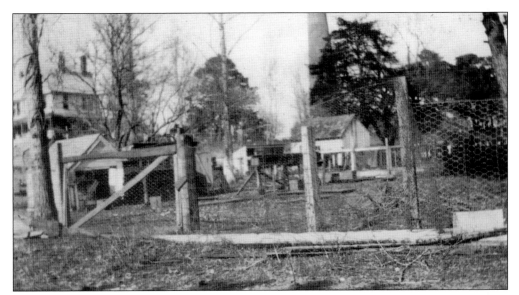

The barnyard located to the east below the lighthouse penned a number of animals. Sheep were allowed to roam freely. Hog killing was a yearly occurrence undertaken by the keepers that usually took place on a Sunday in December. It took several days before each hog was processed. (Quillen.)

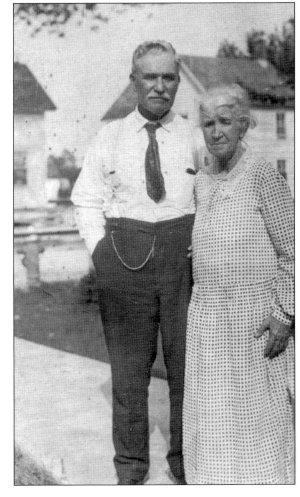

Samuel Quillen and his wife, Libbie, pose in front of their retirement home across from the Baptist church on Chincoteague. The Quillens had seven children, and Samuel helped raise four of his grandchildren. He first came to Chincoteague in 1880 as a sailor with Captain Chandler, working on his boat and seining off beach. (Quillen.)

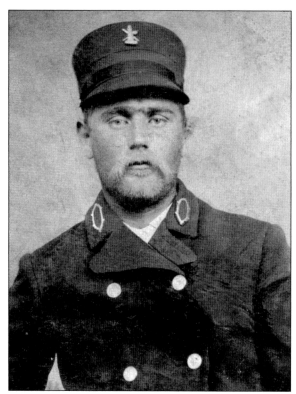

Winred Hopkins came to the Assateague Lighthouse from Sussex County, Delaware, and served as the second assistant keeper for 19 years. He married Ida Virginia Taylor in the Assateague Schoolhouse in 1889. They had five children: Mary Ethel, Walter, J. Hillman, Mattie, and Clifton George. Hopkins was popular and respected by all who knew him. He died of typhoid fever at just 41 years old in 1905. Ida and the children moved to a house Hopkins had purchased for them that included a view of the lighthouse on the east side of Chincoteague. In the image below, Hopkins is assisting with the schooner *Sunbeam* that ran ashore in bad weather. (Jerry Lou Turlington.)

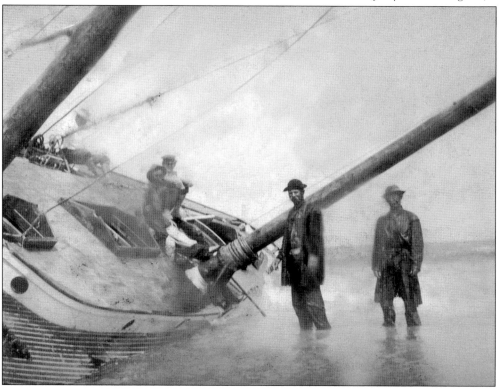

William Major Parker, his parents, and wife Venus Nedab were born free on the Eastern Shore of Virginia. Parker attended Hampton Institute, now Hampton University, for three years before he was appointed second assistant keeper at the Assateague Lighthouse in 1876. He served nine years at Assateague before being transferred to Killick Shoals as the principal keeper. Parker died alone at the lighthouse. He was found kneeling at his bedside as if in prayer. (Hampton University Archives.)

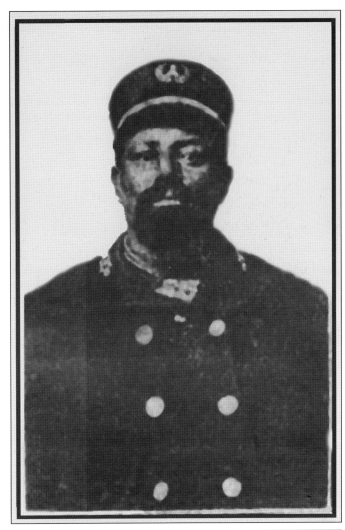

With the advent of World War I, all males had to register with the county. Here is the registration for Walter Wescott, which lists his age, birth date, occupation, and residence as well as his physical characteristics. Keeper Wescott was remembered for his whistle that carried far and wide when summoning his children.

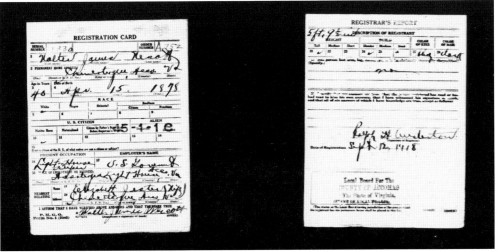

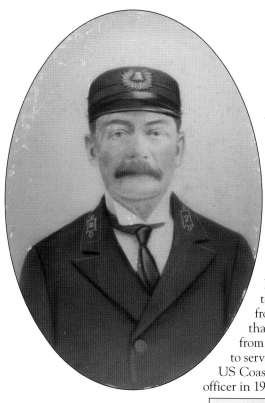

Walter James Wescott, born in New Jersey near the Cape May Lighthouse, entered the service as a cook on a lightship. A husband and father, he asked for a land-based assignment. He became keeper of Fishing Point Lighthouse in 1904 and upon the death of keeper Winred Hopkins was promoted to second assistant keeper. He served until the Assateague Lighthouse was automated in 1933. Wescott was transferred first to Hog Island and eventually retired from Drum Point Lighthouse in Maryland. He said being at the top of the lighthouse when a storm came in from the Atlantic was a "thrilling spectacle" and that there was "nothing monotonous about a gale from the sea." He was the only Assateague keeper to serve both in the US Lighthouse Service and the US Coast Guard. He retired as a senior Coast Guard officer in 1942. (Both, Walter Wescott family.)

William T. Collins first came to Assateague to tend the Fishing Point Lighthouse. When he joined the other keepers at the Assateague Lighthouse Station, he moved into the 1910 keeper's house. He married Jessie Scott, Bill Scott's daughter. Their three daughters (Ada, Margaret, and Ruth) were born in the 1910 keeper's house. (Wells.)

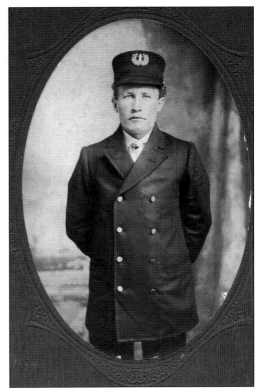

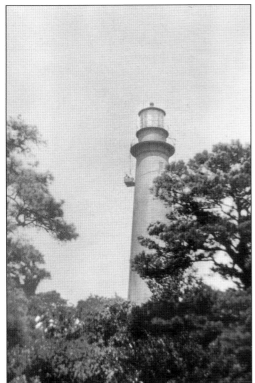

One of the responsibilities of the lighthouse keepers was keeping the lighthouse painted. Here, keeper Collins is shown painting from a scaffold. It is told that at another time, he used a barrel suspended from a rope and fell to the ground. When contracting for this work, one estimate allowed 50 days for painting. (Wells.)

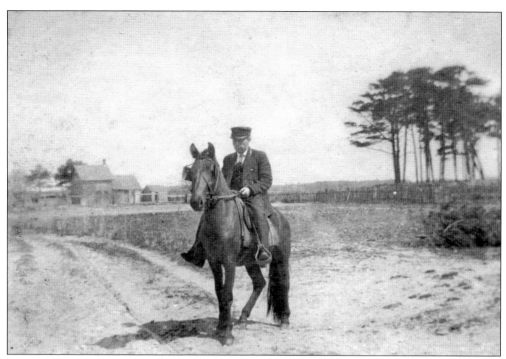

The keepers owned horses for traveling around the island as well as for pulling a cart or wagon. Keeper Collins and the other keepers serviced the post lights at the "hook." At a distance of about five miles, the easiest and fastest way to get there was on horseback. (Wells.)

Keeper William Collins would run the boat across the Assateague Channel to Chincoteague to pick up the mail or supplies. With the school closed on Assateague, he would bring his girls across to attend school. People recall the trouble he had with his motor and how he would leave the boat running while he attended to business. (Wells.)

In this photograph from around 1913, keeper Collins sits on the lighthouse steps while holding his daughters Margaret and Ada. The girls both graduated from Chincoteague High School. If their father could not take them across the channel for school, their mother, Jessie, would row the children across. The girls then had to walk a mile to school. (Wells.)

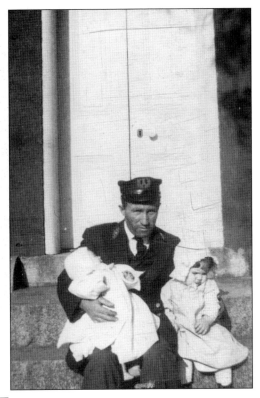

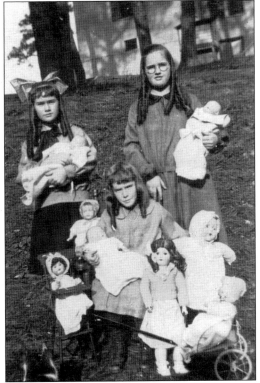

Margaret, Ruth, and Ada Collins are posing with their dolls behind the keeper's house. The Assateague Schoolhouse closed due to low enrollment before the Collins girls were old enough to attend. Their mother taught the girls at home until fourth grade. (Wells.)

Jessie Scott Collins moved to Delaware with her husband when he retired. After his death, she lived with one of her daughters. When she turned 100 in 1983, her grandson arranged for a special visit to the lighthouse with the government. Jesse entered the lighthouse, returned to where the village once was, and looked at the keeper's house where her girls were born. Jessie passed away at 103 years old. (Wells.)

Margaret, Ruth, and Ada Collins pose with their mother, Jessie, in the lighthouse during her visit for her 100th birthday. The girls remembered bringing their father dinner while he tended the light. Jessie claimed that when they took care of the lighthouse, it looked better. (Wells.)

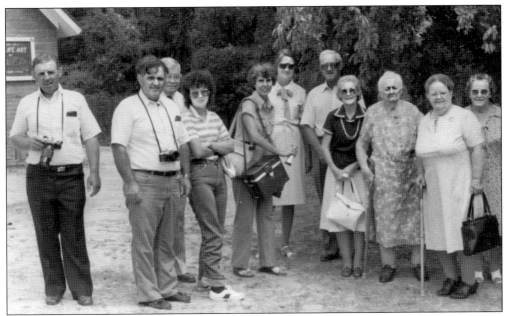

Jessie's extended family, including her daughters, grandchildren, great-granddaughter, and their spouses, celebrated her 100th birthday at the lighthouse. Standing from left to right, they are David Wells, Bill Wells, Martin Wells, Linda Wells Miller, Janet Wells, Mary Elizabeth Wells, Joseph Wells, Margaret Collins Rayfield, Jessie Scott Collins, Ada Collins Wells, and Ruth Collins Wells. (Wells.)

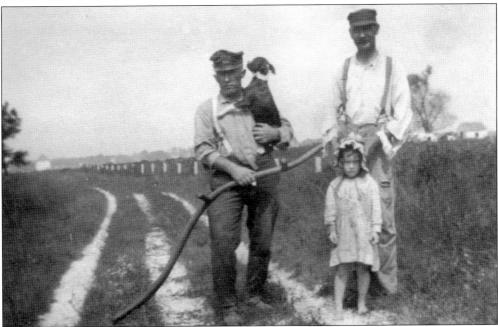

Keeper Collins is carrying a scythe and a dog while walking with keeper Wescott and his daughter Pauline on one of the cart paths. There was fencing around the lighthouse reservation to keep the ponies and other livestock away from the lighthouse at night. The animals came there to escape from the mosquitoes in the marsh. (Wells.)

In celebration of the 140th anniversary of the Assateague Lighthouse, keepers' descendents and members of the community met at the lighthouse and in the Herbert H. Bateman Center to share stories and view pictures. Descendants attending were (first row) Faye Birch, Carole Flores, James Quillen, Ruby Brasure, Ruth Quillen, and Ethan Riley; (second row) Anthony Flores, Debbie Parks, Kacey Givens, Peggy Bernstein, Cari Parks, Nancy Matthews, Jerry Lou Turlington, Tammy Riley, Linda Miller, and William Wells; (third row) Kim Dingus, Kay Dingus, Robert Hurdle, John Nelson Jester, Bill Jones, Tara Riley Ferlag, Ricky Riley, Martin Riley, Larry Jones, and Kirk Jones. (Robert E. Wilson.)

Three

KEEPERS' DWELLINGS

At the time the first lighthouse was built, a small home was constructed for the keeper and his family. This building was partially frame and partially brick. Part of the original house and the cistern was incorporated into the duplex dwelling constructed in 1867. The amount of work at the larger 1867 Assateague Lighthouse required an assistant keeper, and shortly thereafter, a second assistant was added. Until 1892, the second assistant keeper had to share quarters with one of the other keepers. Finally, in 1892, Congress proposed several renovations for the Assateague Lighthouse Reservation. The keepers' dwelling was gutted and remodeled into three six-room apartments with plenty of room for everyone. A bell system from the tower to the principal keeper's quarters was set up. A telephone was eventually installed in the keeper's quarters in 1898, linking it to the Life-Saving Station during the Spanish-American War.

When the Fishing Point Lighthouse keeper was united with the Assateague Lighthouse keepers as the third assistant keeper, a new residence was built for him. It was completed in 1910.

After principal keeper John Anderton and his assistant and replacement keeper, Quillen, retired, keeper Collins and his family moved into the 1892 residence. Plans were already under way for automating the lighthouse. Portions of the lighthouse property were being offered for sale, including the 1910 keeper's house. It was sold along with 3.8 acres when it became a hunting lodge in 1929.

When light was automated, the two remaining keepers were reassigned. In 1933, keeper Wescott went to Hog Island, while keeper Collins went to Smith Island, Cape Charles.

The remaining 18 acres with the 1892 residence was put out to bid, but none of the original bids were satisfactory, so it was put up again with a reserve of $3,000. Again, the highest bid fell short at $1,125. The Lighthouse Service agreed to accept the low bid because the property was located in an isolated area, costly to maintain, and a considered a white elephant. The only property retained was a 100-by-100-feet lot that surrounded the lighthouse tower and oil shed.

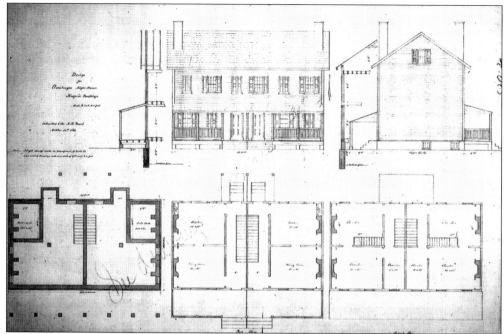

Above are the plans for the duplex keepers' dwelling that was constructed in 1867. Originally built to house two keepers, it served as the home for the principal keeper and two assistants and their families until 1892. A cistern from the original 1833 keepers' dwelling was incorporated into the basement of this house. The front of this dwelling was frame, and the rear was brick. (NARA.)

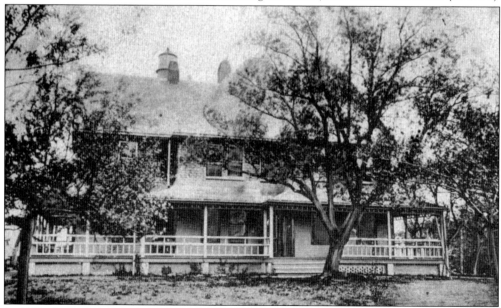

In 1892, the Lighthouse Board finally appropriated money to remodel and enlarge the keepers' dwelling. Two keepers and their families were sharing one half of a duplex. Each family was living in two rooms apiece. After several recommendations for additional housing for the keepers, it was gutted and remodeled. The additions provided three six-room apartments to accommodate three keepers and their families. (Robert E. Wilson.)

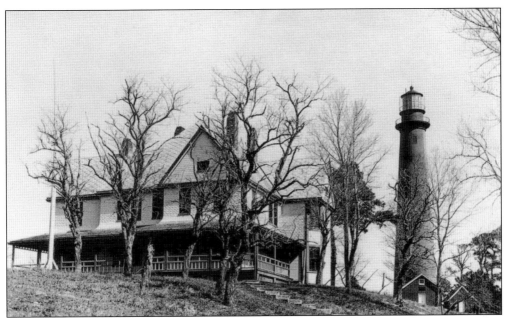

The 1892 dwelling was an impressive building. It was referred to as the keepers' mansion. When the lighthouse was automated, it was offered to other government agencies, but none were interested. Hog Island keeper Hilary Quillen died, leaving behind a wife and five children. With no pension or death benefits available, his widow was hired as a caretaker and lived in the keepers' house until it was sold. (The Mariners' Museum, Newport News, Virginia.)

In 1933, the 1892 keepers' dwelling and 18 acres on Assateague were offered for sale for the second time at $3,000. Calvin L. Twilley submitted the higher of two bids at $1,125. The government, weighing the cost of maintaining the structure, accepted the bid. In 1934, Calvin Twilley moved one section of the dwelling to Chincoteague where it became his feed store, while the remainder was later torn down. (MJC.)

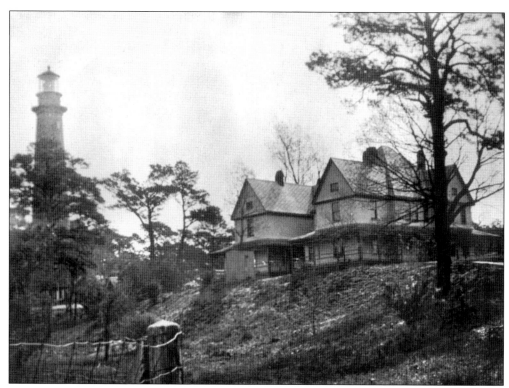

Above is the 1892 keepers' dwelling as viewed from the village. Visible is part of the 4,210 feet of fencing enclosing the lighthouse property. There was also 800 feet of fencing surrounding the barnyard. In 1957, the remaining sections, foundation rubble, septic tanks, and cisterns were bulldozed, filling in the old basement on lighthouse hill. (Walter Wescott family.)

Seen here is Jimmy Quillen, grandson of keeper Quillen, at the old hand pump next to the keepers' dwelling. There was a 26-foot-deep well to the rear of the assistant keeper's quarters. There were only a few shallow wells on the island. People caught rainwater, which was stored in cisterns. (Quillen.)

44

Margaret and Ruth Collins are standing in front of the 1892 keepers' dwelling viewed from another side. The Lighthouse Service provided the property with fruit trees, ornamental bushes, and hedges. The keepers were responsible for keeping the lawn mowed and everything in good condition. The Collins moved into this house in the 1920s. (Wells.)

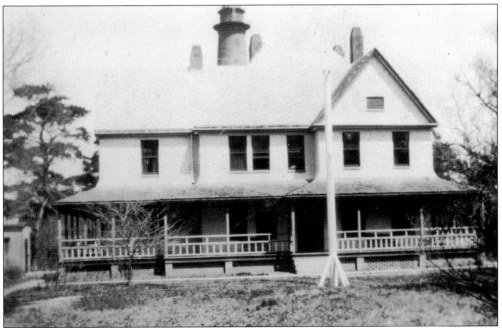

This section of the 1892 keepers' dwelling was closest to the 1910 keeper's cottage. Originally occupied by the Quillen family, it was later occupied by the Collins family. In 1898, a telephone line was installed from keepers' quarters to the Assateague Beach Life-Saving Station. It was installed for national defense during the Spanish-American War. (Wells.)

The 1910 keeper's cottage is pictured while it is under construction. Visible in the rear are some boards and a wheelbarrow. The house was made with concrete walls and features a ground-level basement under most of it. It also included a kitchen, living room, dining room, and three bedrooms. (Wells.)

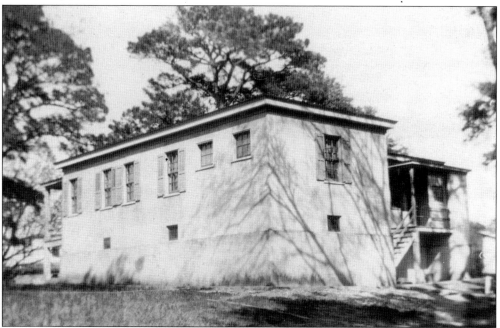

The remaining keeper's cottage was completed in February 1910 at a cost of $6,500. When keeper Collins from the Fishing Point Lighthouse was united with the staff at Assateague as the third assistant, he moved into this house and was later joined by his wife, Jessie Scott. Their three daughters were born here. (Wells.)

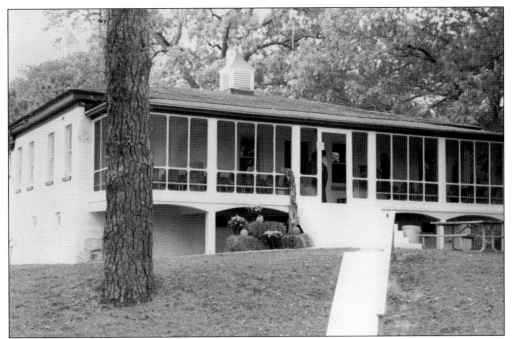

In 1930, James W. Atkinson was hired to manage the 1910 keeper's cottage as a hunt club. He lived in the house with his family and could accommodate up to 20 hunters. Atkinson boarded several dogs such as Chesapeake Bay retrievers, springer spaniels, and beagles for the use of the hunters. It is said that during hunting season, he would sow 20 bushels a day of corn, wheat, and barley in the marsh to attract waterfowl. (CNWR.)

This keeper's cottage has served many purposes. It began as a private dwelling followed by a hunting lodge. After years of disuse, the house was cleaned and renovated. Water, telephone, and electricity were installed, and it again became a private home. Since then, it has been used for temporary housing for US Fish and Wildlife Service interns. (Nick F. Grief.)

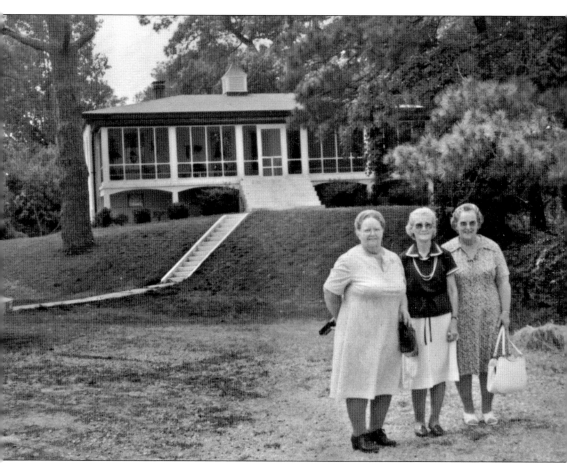

In 1983, on the occasion of their mother's 100th birthday, the Collins girls revisited the home where they were all born. The oldest girls graduated from high school before their father was transferred to Cape Charles. Ada attended normal school, became a teacher, and taught school in Chincoteague for seven years. She married Martin Wells from Delaware and taught school in Lewis, Delaware, until she retired in 1974. Margaret married Marvin Rayfield from Cheriton, Virginia, near Cape Charles, where her father had been transferred. She had one son and cared for Jessie later in life. Ruth finished high school in Cape Charles, and when her father retired due to illness, she moved with her parents to Milton, Delaware. She married Nailor Wells and raised two sons. Their mother, Jessie Collins, had an interest in photography and left well-documented evidence of her life on Assateague to her children. (Wells.)

Four

ASSATEAGUE VILLAGE

The small community at the base of lighthouse hill on the western shore of Assateague Island had its beginning in 1794 when four men purchased 163 acres from Thomas T. Gore. This parcel was the core of Assateague Village.

Early life on the island was primitive. Homes consisted of one room with a door, a window, and an opening for smoke to escape. Fireplaces were made of stones or shells stacked in one corner of the room to provide heat for warmth and cooking. At first, there were no floors except for the clean ocean sand. Clamshells filled with lard oil and a piece of cloth called "sows" provided light. Candles were too expensive to buy, though some were homemade by using myrtle berries and lard.

The seafood industry grew. By the outbreak of the Civil War, it was the primary source of income for both Assateague and Chincoteague Islands. With the coming of the railroad, the barrier islands became a mecca for sportsmen from Washington, New York, Philadelphia, and Baltimore in quest of waterfowl.

Homes did improve in size and structure, but life was still primitive. There was no indoor plumbing, and residents kept warm by burning wood. It took very little time to restart the fire in the morning because kindling was always handy. One advantage was that there were no expenses after the light was extinguished at night.

The people of Assateague were quite independent. They raised corn, wheat, and rye. Everyone had a garden. They grew snap beans, beets, carrots, onions, cabbage, pumpkins, and squash. In the fall, they dug turnips, potatoes, and sweet potatoes and covered them in caves in the dunes, preserving them like in a root cellar. Chickens, ducks, and geese were kept for meat and eggs. Apples, pears, and peaches were canned in glass jars as well as jellies, jams, and pickles. Children hunted for the eggs of the plover and marsh hen. Fishing was only done to get food for the table. If more than enough for one meal was caught, it was salted for later use.

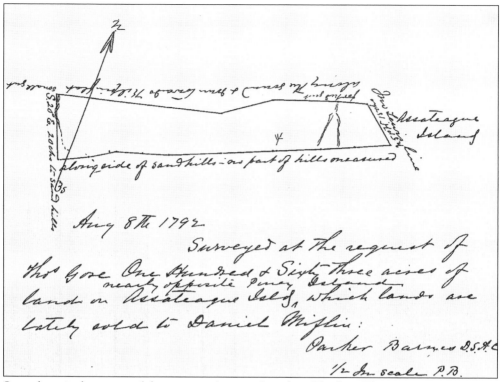

Seen above is the survey of the property first purchased in 1794 from Thomas T. Gore. Located between the lighthouse property and Assateague Channel across from Piney Island and Chincoteague, it became the heart of Assateague Village. Lots were divided and laid off. It was originally settled by members of the Lewis, Birch, and Cherrix families. Some families came from Maryland and Delaware as well as Virginia. (CNWR.)

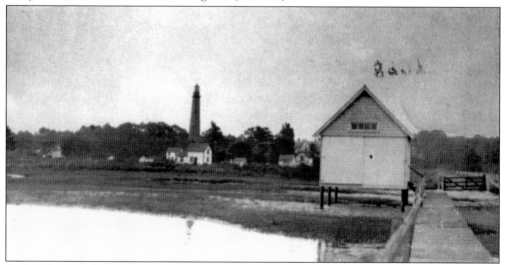

In this photograph is the government boathouse and dock on Assateague Channel around 1920. Right of the boathouse is the shell road leading to the lighthouse. To the left is the village church and schoolhouse with the keeper's mansion on the hill. At night, the village was never dark. One former resident described it as a "perpetual full moon." (CNWR.)

50

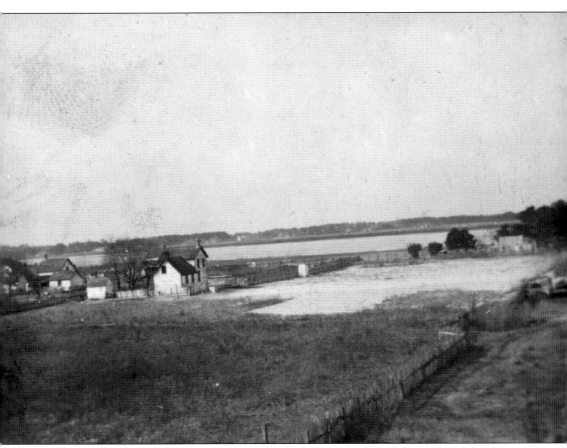

Pictured above is the lower section of Assateague Village facing the old Assateague Inlet. There are no streets, only footpaths between houses. Many people who fenced their yards used stiles instead of gates. Noticeable in this picture is a cornfield and other farmland. When the villagers moved to Chincoteague, most of these homeowners took their houses with them. They would jack the houses up, take them to the water's edge, place them on a barge or monitor, and float them across to Chincoteague where they would join the houses on Chincoteague, which are visible at the top of the picture. Many of these houses have been altered and remodeled but can still be seen on Eastside Road and Church Street. Today, this area is wooded, hiding evidence that this village ever existed. (Wells.)

When the school opened in 1890, it included first through sixth grades. Some children were as young as three years old in order to meet the requirement of 40 pupils, the number required by the county in order to receive public funding. The county provided a teacher at $25 per month. (Quillen.)

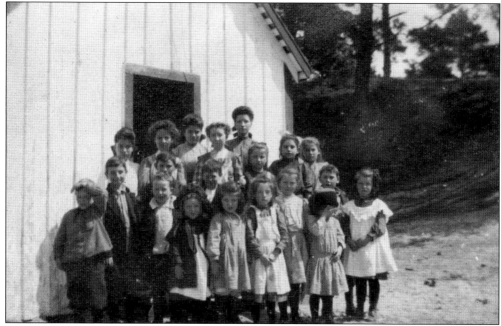

When not in school, the children on Assateague would pick berries, clam, or crab, while some enjoyed swimming. They played games like Red Rover and tag. Children often made their own toys, and girls constructed paper dolls using the Sears catalog. They also enjoyed helping make taffy (Jones family.)

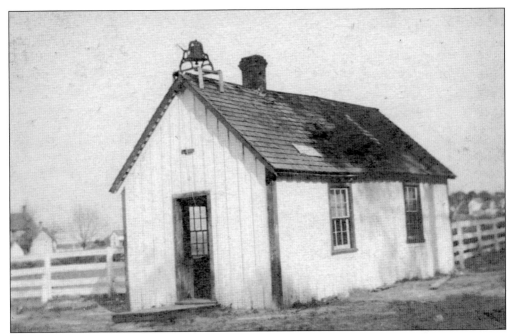

Assateague Schoolhouse was built in 1890 by the men of Assateague Village. Located at the base of the lighthouse hill, it served as a gathering place for the community. It functioned as a school, church, and social hall. Prayer meetings were held on Thursday night. On Sunday, there was Sunday school and services. (Wells.)

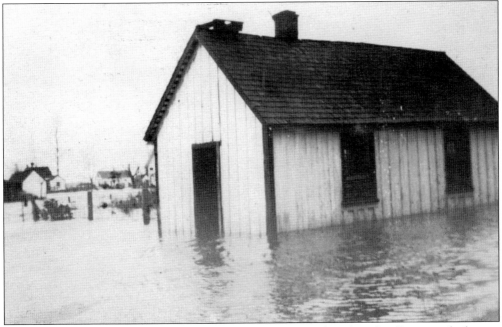

Located on low land next to a small gut, it is not surprising that the schoolhouse and adjacent homes would flood during a bad storm. Fortunately, the school and many of the homes had sand floors that drained quickly. Members of the community provided the wood for heat, and the lighthouse keepers supplied coal for lighting. (Wells.)

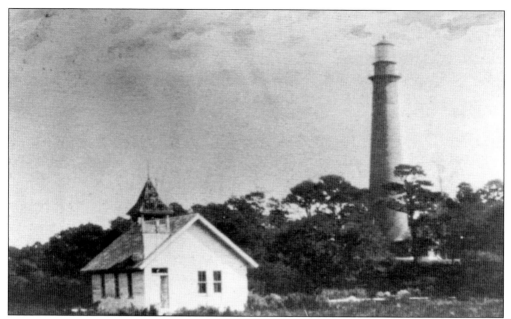

In 1919, trustees of the Union Baptist Church, Rev. O.W. Sawyer, and Assateague residents pledged enough money to build a meetinghouse on Assateague. A parcel of land 50 by 50 feet was purchased from George Hopkins and his wife, Sudie Cherrix Hopkins. The church was completed at a cost of $1,200. The only marriage performed in the church was that of Ida Jones and Marvin Jester. (Kirk Mariner.)

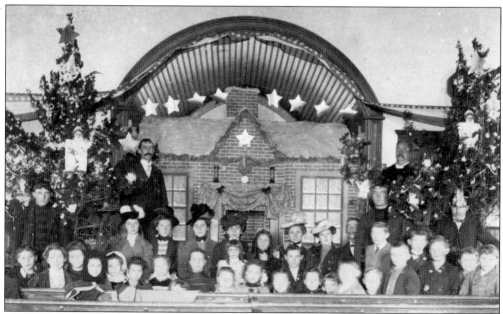

The Assateague church's interior is pictured above during a Christmas pageant. At Christmas, children usually received one toy and either an apple or orange. The Baptist minister from Chincoteague conducted services twice a month. Occasionally, the Methodist minister would serve. Sunday school was conducted every Sunday, and 35 families attended prayer meetings on Wednesday night. (Quillen.)

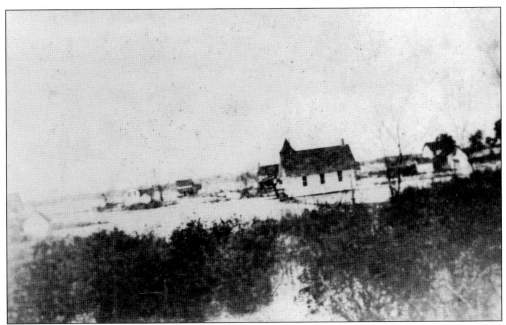

Above is a winter scene of the Assateague church with some village houses in the background. The floor of the church was sand, which was raked and straightened up before services. The church was located back from the water's edge near the boundary with the lighthouse property. (Wells.)

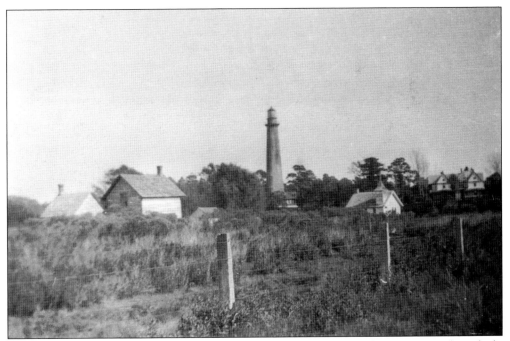

This is a view of the lighthouse taken from the shell path leading from the government boat dock. Some village houses are seen on the left, and the 1892 keepers' dwelling is visible on the far right. The church sits at the base of the hill in front of the keepers' dwelling. (Wells.)

The church on Assateague was used until 1922. Elijah Hill purchased the building and barged it across the Assateague Channel to Eastside Road, Chincoteague. It was remodeled into a home for use by his family. Today, it is a summer rental for tourists. It can be seen from the lighthouse grounds. (MJC.)

Along with the village, most traces of cemeteries on Assateague are gone. On a slight rise near the location of Bill Scott's house is a small corner marker that marks the village cemetery. The cemetery ran 63 feet on the side. Former residents recall the following people being buried there: Henry Birch's wife and three of their children, Jesse McGee, George Elliott, and Roxilla Birch Scott. (MJC.)

Located about 100 yards northeast of the Assateague Bridge is a cemetery with three remaining headstones. John A. Jones, an influential person in the community, was referred to as John "Assateague" Jones. He served as an assistant lighthouse keeper and was the first keeper at the Assateague Beach Life-Saving Station. (MJC.)

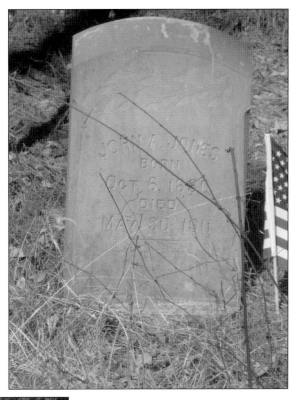

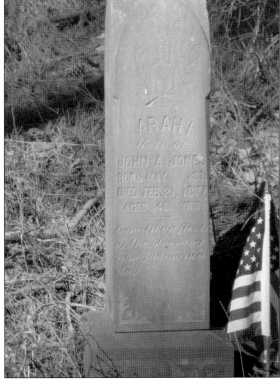

"Gone like a flower of the blooming June fading in a day." Arah Lewis, wife of John A. Jones, was the daughter of Isaac Lewis. Upon her death, Jones divided the land she inherited among their six children: Rebecca Jones Whealton, George W. Jones, Howard Frank Jones, Isaac Daniel Jones, Joshua Burton Jones, and John D. Jones. Each received two lots in the northern part of the village. (MJC.)

Thomas Watson was a member of Company A, 1st Regiment Loyal Eastern Shore Volunteers. Upon enlisting, he received $100. After his death, his wife, Delany Lunn Watson, received a pension. Delany was the daughter of "James Alone," the boy who was found washed up on shore, bound to a ship's hatch thought to be from the shipwrecked *Juno*. Raised on Assateague, he changed his name to James Lunn. (MJC.)

Ida Watson Jones, daughter of Thomas Watson, married Howard Franklin Jones, raised a large family on Assateague, and moved to Chincoteague in the early 1930s. Her grandson called her "the sheriff of Assateague" because she demanded good manners and kindness from all the children. Although a small woman, when she spoke, others listened. (Frank Williams.)

Seated in front of a tent at the base of lighthouse hill are, from left to right, Jennie Leonard, Nevada Bowden, Virginia Wescott, Edna Birch, Donald Preston Bowden, and Spot the dog. Virginia was the lighthouse keeper's daughter. The other children could have been visiting relatives on Assateague. (Lola Mae McGee.)

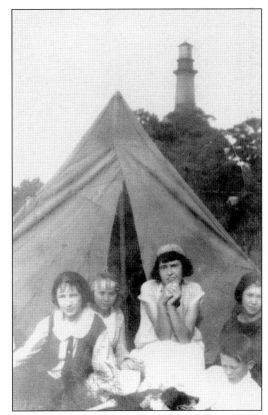

Bill Scott, seen below with a pipe, was the owner of the general store on Assateague and had a cart he used to carry supplies—and sometimes people. Here, everyone appears dressed for a special outing. Eva Kate Hancock Jones (with glasses) and her husband, Joe Jones Sr., are seen with several of their neighbors. (Lola Mae McGee.)

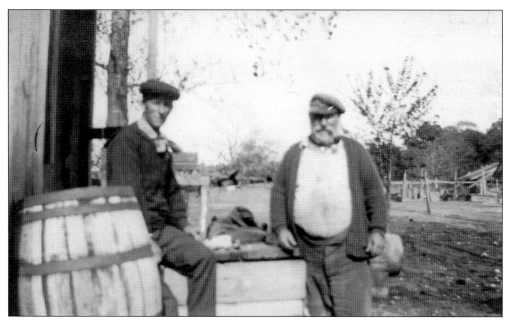

Washington Elliott and his neighbor Bill Scott enjoy a chat beside the rain barrel. Bill Scott did several different things besides operating his store. He had a garden, fished, gathered oysters, cut wood, and raised livestock on a small scale. If he did not have what a customer needed, he would get it. (Quillen.)

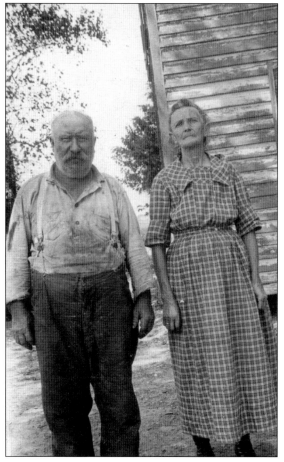

Bill and Mime Scott were known by everyone. He was the storekeeper and the village character that everyone seemed to have a story about. Mime kept a special candy jar in the store for the children that she used to help soothe skinned knees and cure homesickness and fright. (Wells.)

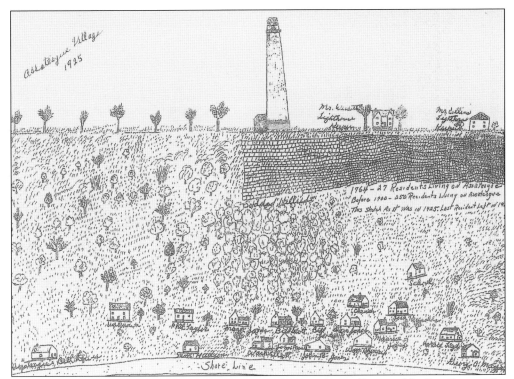

This ink drawing of Assateague Village as it looked in 1925 was illustrated by Roy Jones. The Jones family moved to Chincoteague in 1933, the last "family" to leave Assateague. Storekeeper Bill Scott and his wife, Mime, remained; the last people to leave Assateague. Roy and his sister Blanche are the only surviving residents of Assateague Village. Eula Jones, their younger sister, was the last child to be born on Assateague in 1931. (Roy Jones.)

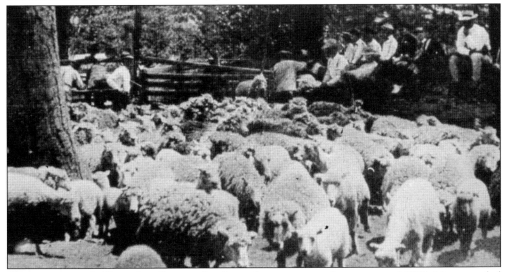

Sheep penning, held yearly in June at the close of oyster season, began around 1850. Men rounded up the sheep, placed them in pens, and sheared them. Some of the wool was spun and shipped north, where it was made into blankets and sold. The remainder of the wool was used by villagers. Early pennings were only for men. Later, it became a community affair. (NPS.)

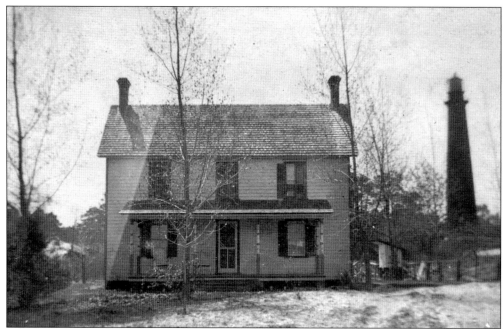

Seen above and below is Bill Scott's house viewed from the front and rear. In 1897, his house burned almost to the ground. The men of the community got together and rebuilt it for him. The house had five rooms with two brick chimneys but no plumbing or electricity. It had a 10-foot driven well with a pump. In addition, he had a wagon shed, poultry house, a storage shed, and two other small sheds. Looking at the front of the house, immediately to the right was the village cemetery where Scott's first wife was buried. Directly behind it is the lighthouse. The Scotts were the last people to leave the village. When the US Fish and Wildlife Service took over, they moved to Delaware with their daughter. An inventory of the house noted that the interior was surprisingly neat and well maintained with papered plaster walls and painted trim. (Wells.)

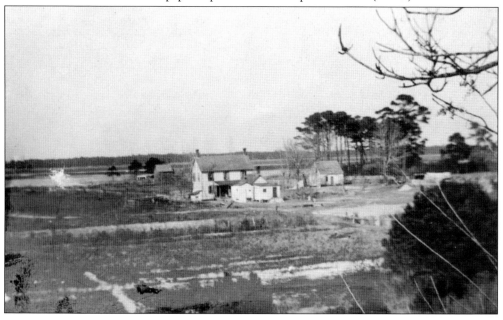

Mime was born Jemima Adams on Main Street on Chincoteague. When she married Bill Scott, she and her daughter Jessie moved to Assateague. Jessie was about six years old. Those who knew her recall how nice Mime was to everyone. (Wells.)

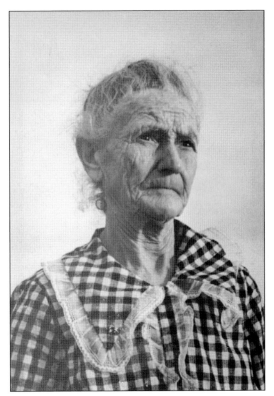

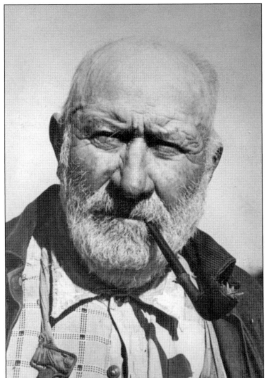

Bill Scott was the son of Benjamin Scott, the Civil War veteran who lived to be 106 years old. Bill was known for always having his pipe with him and being a tad untidy. One story told is how Mime would fix him a breakfast of Guinea hen eggs with some for Bill and some for the dog. When Bill was finished, if the dog left any, he would help himself to the leftovers. (Wells.)

The McGee family originally came from Delaware and initially settled on Chincoteague before moving to Assateague. George McGee and his wife had 10 children, many of whom worked on the water. Their house was located just to the right of the bridge to Assateague. In the 1920s, it was floated to Chincoteague and is now on Eastside Road. The McGee men, with sons, sons-in-law, and grandsons, are pictured below, from left to right, (first row) Wayne Merritt, Steve Merritt, Mordaci "Mock" McGee, Fred McCabe, Russell Fish Jr., and George Dewey McGee; (second row) George White, Elwood "Shan" McGee, Russell Fish, Floyd Conner, David Fish, and Harvey McGee. (Carlton "Cork" McGee.)

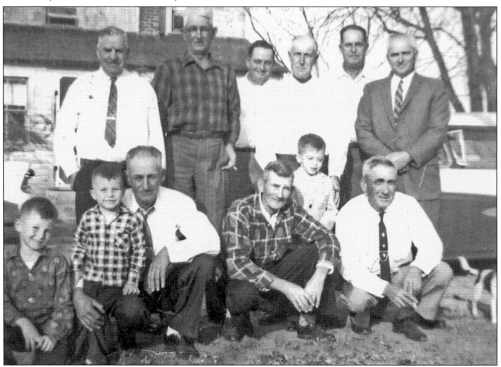

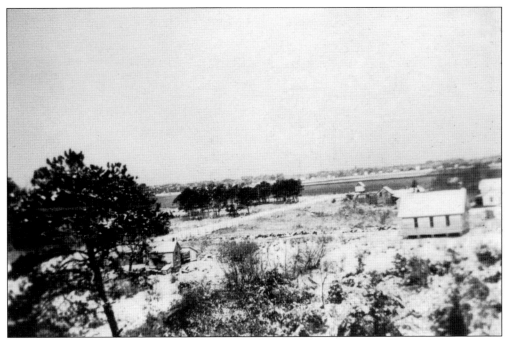

The village is covered with snow against a background of Assateague Channel. Snow is not a common occurrence. There are years when there is hardly any snow and other times when there is plenty. During the winter, residents burned wood for heat, as none of the homes had central heat. (Wells.)

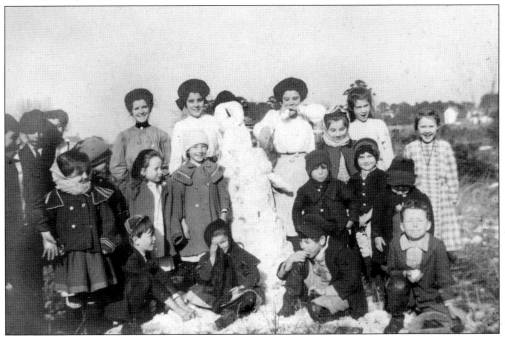

Unidentified children on Assateague show off their snowman in the photograph above. The children in the first row are shown playing with the snow, making a snowball and even tasting it. (Wells.)

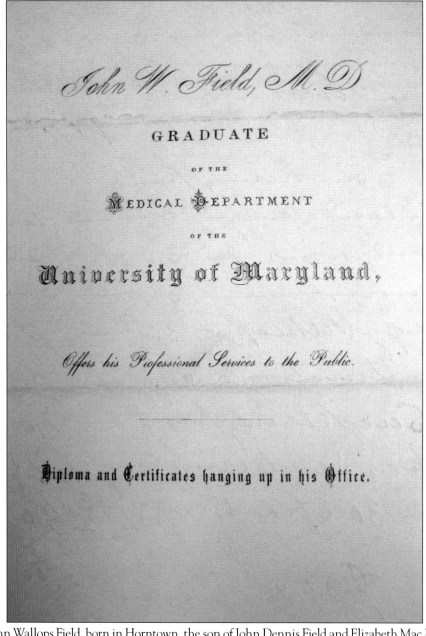

John W. Field, M.D

GRADUATE

OF THE

MEDICAL DEPARTMENT

OF THE

University of Maryland,

Offers his Professional Services to the Public.

Diploma and Certificates hanging up in his Office.

Dr. John Wallops Field, born in Horntown, the son of John Dennis Field and Elizabeth Mac Master, was a direct descendent of Anne Toft's daughter Annabella. He grew up on the land given to Annabella by Colonel Jenifer and Toft. Dr. Field studied medicine at the University of Maryland. His brother Samuel M. Field became a dentist. John Field practiced medicine in Horntown and assisted as a civilian doctor during the Civil War. After the war, he moved to Missouri where his three children—John Corbin, Samuel Burton, and Nellie Field—were born. He returned to the shore in the mid-1880s and became a member of the Assateague and Chincoteague communities. He practiced medicine on Chincoteague, taught school on Assateague, briefly published a newspaper on Chincoteague, and was the Chincoteague postmaster for 14 years before his death. (Rare Book, Manuscript, and Special Collections Library, Duke University.)

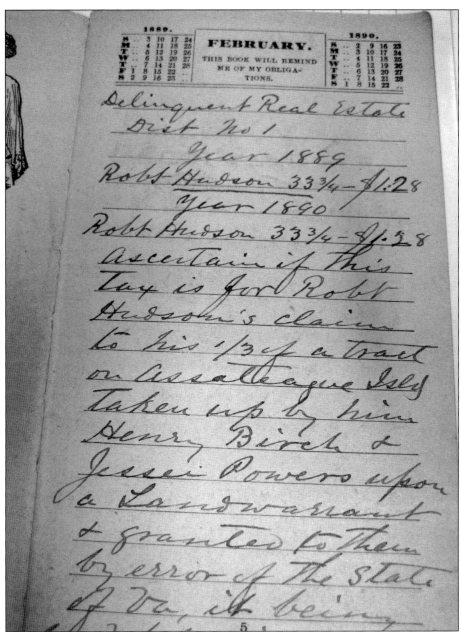

	1889.				FEBRUARY.		1890.			

THIS BOOK WILL REMIND ME OF MY OBLIGATIONS.

Delinquent Real Estate
Dist No 1
Year 1889
Robt Hudson 33 3/4 – $1.28
Year 1890
Robt Hudson 33 3/4 – $1.28
ascertain if this
tax is for Robt
Hudson's claim
to his 1/3 of a tract
on assateague Isld
taken up by him
Henry Birch &
Jessie Powers upon
a Landwarrant
& granted to them
by error of the state
of Va, it being

Dr. John W. Field and his brother Dr. Samuel M. Field began purchasing land on Assateague Island in 1885. They acquired land through direct purchase, warrants from the Commonwealth of Virginia, and defaulted lands. Perhaps their idea was to reconstruct their ancestors' patent. Anne Toft was their great-great-great-great-grandmother. Dr. Samuel M. Field transferred over 2,000 acres to his nephew Samuel Burton Field in 1909. Samuel B. had already started acquiring some land on his own. When Dr. John W. Field died, he left his land to his daughter Nellie. All the land below the state line, with the exception of the village and the government lands, belonged to the Fields. Samuel B., a successful clothing manufacturer in Baltimore, hired an overseer, fenced in the property, and established a livestock farm raising cattle and horses in 1921. (Rare Book, Manuscript, and Special Collections Library, Duke University.)

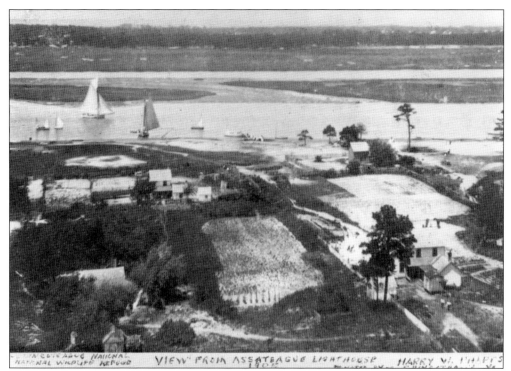

An overview of Assateague Village looking from the lighthouse toward the north shows several cultivated areas where residents grew crops like corn. Chincoteague is just across the water at the top of the picture. Living on the water, boys learned early to pole or scull a boat across the water. (CNWR.)

This is another example of a house barged from Assateague to Eastside Road. Originally, this home was located near the beach, not in the village. It was moved by jacking it up and floating it on a barge. Sallie Hancock Lewis purchased the house for $500 in the 1920s. (MJC.)

John D. Jones, a son of John A. Jones, married Annie Pruitt. He moved to Cheriton, where his youngest children were born. He served in the US Coast Guard and the reserve. Jones retired to Chincoteague. He died on his boat and is buried in Bunting Cemetery on Willow Street. (Vernon Jones.)

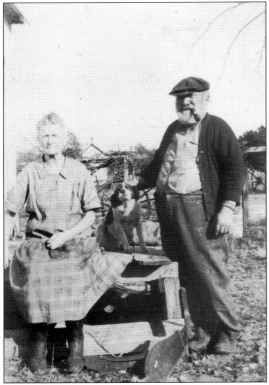

Mime and Bill Scott are shown here sitting in their yard with their dog. Scott was considered a generous man. In the fall, he would hold his annual oyster roast for business associates, traveling men, and friends. This event drew people from Chincoteague and the mainland. "Big Bill," as many called him, provided a feast and entertainment for all. (Wells.)

Little Milton Clear looks like he has found something he had been searching for in the weeds in this image from the early 1920s. Milton's father, George, came to Assateague as a blacksmith for one of the fish factories and married keeper Samuel Quillen's daughter Edith. Milton became the postmaster at Chincoteague. (Quillen.)

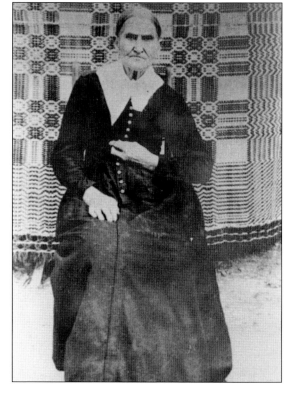

Eliza Reynolds, born on Assateague, was the daughter of Joshua and Sarah Lewis Whealton. She was first married to John Lewis and later to Richard Reynolds. Using herbs and roots, she was known as a folk healer and for her healing powers. Reynolds was even said to have cured cancer. Her secrets died with her. (Kirk Mariner.)

Mime and Bill Scott were the last to leave the village in 1943 when they were about 80 years old. Before they moved, the men from the Coast Guard would check on them and invite them out to the movies. They went to Delaware and lived with their daughter Jessie and her husband. They died in Millsboro, Delaware, and are buried there. (Wells.)

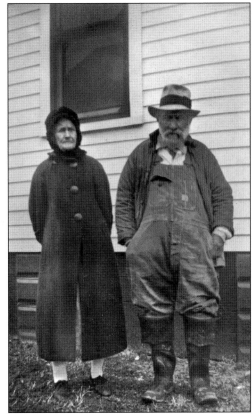

Ruth Collins is driving a calf while riding in a small cart along the shell path. The children on Assateague enjoyed the same toys that children on Chincoteague and the mainland had, such as tricycles and doll carriages. They also had a number of different animals to play with or tend to. (Wells.)

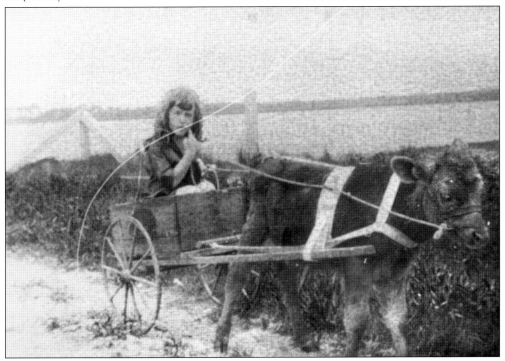

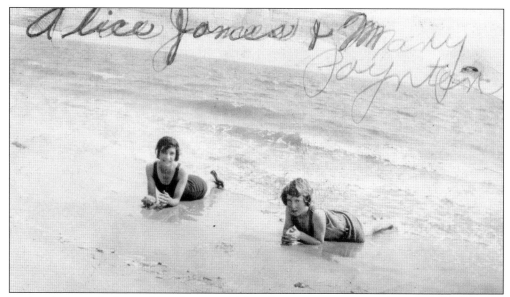

In the photograph above, Alice Jones and Mary Poynter are enjoying their day at the beach. Their bathing costumes, the term for their outfits at the time, indicate that this picture was probably taken during the mid-1920s. Alice was keeper Quillen's granddaughter. As a rule, most boys learned to swim early while many girls never learned to swim. (Quillen.)

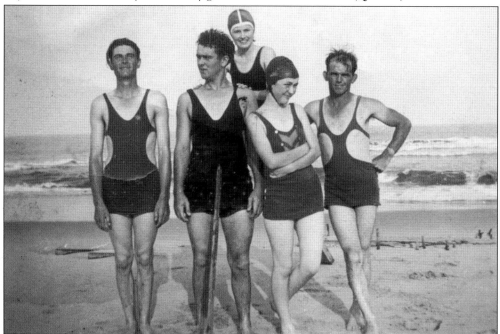

After the village was abandoned, people from the mainland and neighboring islands would often boat to the beach to enjoy the sun and surf. Here, from left to right, William C. Moore from Chincoteague; Vincent L. Mariner, Beatrice Chapman Mariner, and Gwendolyn "Dollie" Mariner from Greenbackville; and W. Rhodes Hastings from Wattsville pose at the water's edge in the mid-1930s. Rhodes's bathing suit is not all that different from the other two men, except he is wearing his backwards. (Kirk Mariner.)

Raymond Jones was the third of four children born to Maurice and Agnes Andrews Jones. In 1933, they were the last family to leave Assateague Village. His sister Eula was the last child born on the island. Raymond joined the Army in World War II even though he was offered a deferment, claiming he was not a coward. Much to his family's regret, he was killed at the Battle of the Bulge at 19 years old. (Roy Jones.)

In the image above, Roy Jones and Frank Williams share their stories of life on Assateague. Roy and his sister Blanche are the last two to have lived in Assateague Village. Frank, their cousin, spent many a day poling across the channel from Piney Island to visit his grandmother and cousins. Their boyhood tales of skiing down the dunes on barrel staves and enjoying ice tea with their grandmother delight all. (MJC.)

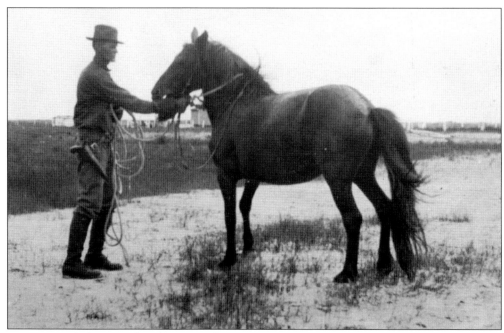

Cooper H. Oliphant was hired by Samuel B. Field in 1921 to be the manager of his stock farm and to collect rents from the people leasing the flats and oyster grounds. He was known to dress like a cowboy, ride a big horse, and carry a big gun. Some believe this is a picture of him. (CNWR.)

Samuel B. Field built a cottage near the old Assateague Beach Life-Saving Station for his overseer. A group of cattle are seen grazing near the bungalow in the image above. Adults in the village did not like the new fencing and restrictions placed upon them when this farm was established. Children said they were aware of Oliphant watching them, but he only observed what they were doing and never bothered them. (CNWR.)

Five

WORKING ON THE WATER

Living at the water's edge, it seems only natural that people would turn to the water, abundant with fish and shellfish, to make a living. Oysters were their first big commodity. Harvesting oysters and selling to markets in the north, such as New York, Philadelphia, and Baltimore, brought the islands a vast amount of income as well as recognition. This lifeline contributed to their siding with the Union during the Civil War.

Oysters were first planted in 1864. In 1883, the government conducted a survey, called the Baylor Survey, of naturally productive oyster beds, rocks, and shoals and reserved these areas for public shellfish harvesting, which cannot be leased or used for other purposes. Then, in 1884, the General Assembly allowed for the private leasing of oyster grounds. Private lands and survey plots were leased and recorded at the clerk's office in Accomack County.

The fish factories located on the southern end of Assateague Island commercially processed Menhaden. Menhaden, also known as bunker, is a small oily fish found off the Atlantic Coast. Ships took to the sea, scooping up vast schools of fish in mile-long nets. Menhaden filled ships to capacity in a matter of days, reaping enormous profits for their owners.

The ships brought their catch to the fish factory. After unloading their catch, the fish were cooked and then pressed to extract the oil. The remains were removed to a drying shed. Oil was placed into barrels to be used in the making of paint, as a fuel for lighthouses, and for industrial or medicinal use. The dried, crushed flesh and bones were put into sacks to be used as fertilizer. The silting in of Toms Cove prevented larger ships from entering. Countering that, the Conant Bros. dismantled their factory and moved to Chincoteague. The Seaboard Oil and Guano Co. burned in 1916.

Duck hunting may also be called working on the water. At first, the market hunters made a good living killing hundreds of ducks a day. Later, they shared their knowledge with visitors as hunting guides.

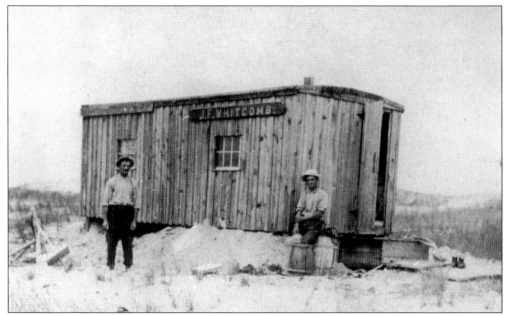

Oyster beds were leased lands, licensed and recorded in the clerk's office in Accomack County. Sometimes, license holders subleased them to others. Watch houses were where an owner or employee could keep an eye on the oyster beds and also have a convenient place to stay. (Quillen.)

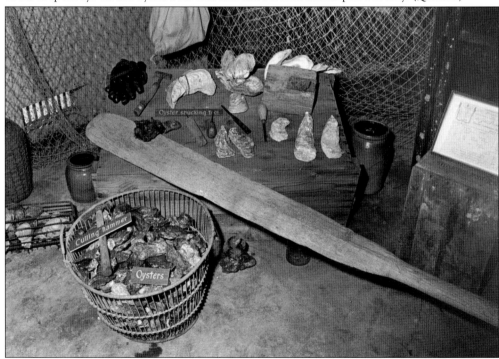

This is a display of oyster harvesting tools. Oysters were carried to the boat in an open metal bushel basket. The culling hammer was used to free individual oysters from the oyster bunches gathered from the rocks. To open an oyster, shucking tools were used. Oysters originally sold in their shells were later shucked and placed in cans. (CNWR.)

On Assateague, oysters were first harvested and sold in the 1830s. Watermen began planting them in 1864. They would plant oyster shells (rocks) for the spat (spawn) to catch on and grow. The season for oysters is the first of September through May 15. Many oystermen would turn to clamming in the off-season. (CNWR.)

At one time, as many as 15 to 20 boats could be seen working oysters in Toms Cove. Some oysters were sold to city markets by locally owned boats while others sold to "buy boats" owned by commission merchants or canning factories. In 1885, oysters were first shipped by rail. (CNWR.)

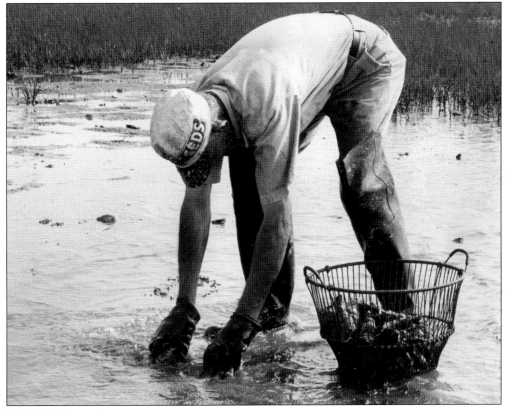

"Down the bay" boats with a crew of four to six men sailed down the coast as far as Smith Island, Cape Charles, oystering or clamming. Each trip lasted about a week. In the fall, they went to get seed oysters to bring back and plant on oyster grounds. They could carry 500 to 1,200 bushels of oysters on monitors or barges. (Lillian Rew.)

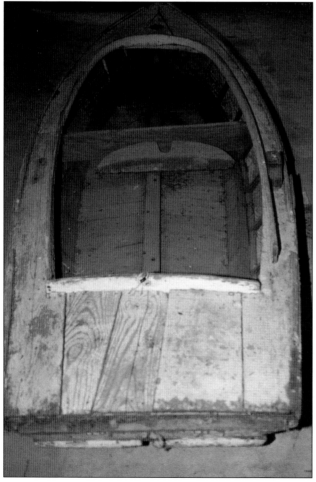

This is an example of a dead-rise bateau used in duck hunting. A bateau was a small flat-bottom boat with a shallow draft that could be used around the marshes. It was often pointed on both ends and came in a number of different sizes. It was also known as a sneak boat. (CNWR.)

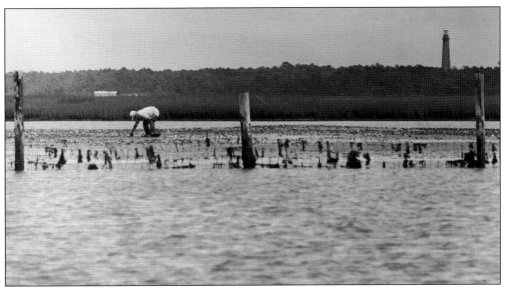

There are several different ways to harvest clams: signing, raking, wading, tonging, and dredging. Signing clams begins in early spring, which is done at low tide at the water's edge. One way to sign clams is to look for a depression in the sand that looks like a keyhole. The clammer then uses a gaff hook to dig out the clam. An experienced clammer can identify several different signs. (CNWR.)

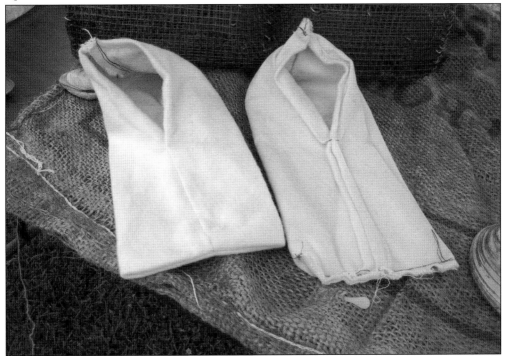

Cotton-flannel moccasins are worn when wading clams. They are purchased in pairs, usually several at a time because a wader in an area with a plentiful supply of clams, usually near oyster rocks, can wear them out quickly. Wading is done in water that is anywhere from knee to chest high. (MJC.)

Raking clams is done in the same waters as wading; the only difference being that a long-handled rake is used. The rake is dragged through the sand while the clammer walks backwards. When a clam is hit, the rake digs it out. The rake is shaped so the clam stays in a curved pocket. Clamming is a year-round activity. (CNWR.)

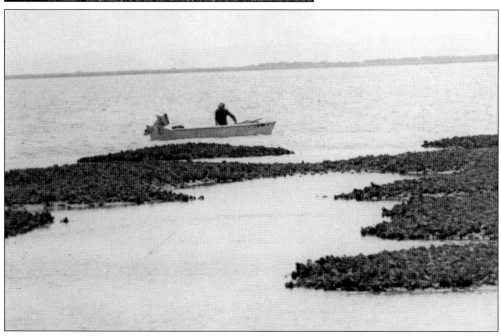

This man, out in the water near oyster beds (rocks), is probably wading clams. Clams and oysters are found in the same water. A good wader can catch up to a thousand or more clams a day. Wading was done by feeling for the clam with your foot, then sliding the clam up your leg to retrieve and place in the boat. (CNWR.)

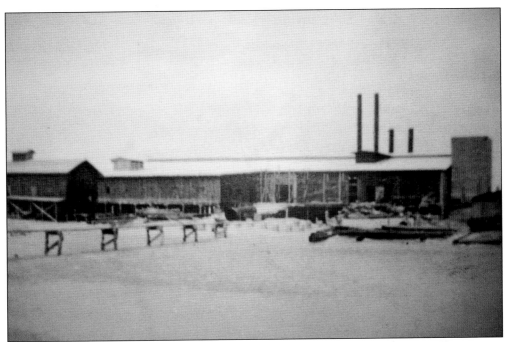

The first fish factory was operated by the Seaboard Oil and Guano Company of Reedville, Virginia. It opened in May 1912 and burned in 1916. The company did not rebuild after the fire. Cement pilings remained, but they are now almost entirely gone. The factory operated seasonally from May through November. (Jones family.)

This building housed the kitchen and dormitory area for the workers at the fish factory. There were also some houses in the area of the plant, but some workers commuted from the village. The men worked two shifts—50 men worked during the day while 25 worked at night. (Jones family.)

In 1919, Conant Bros. of Chincoteague built the second fish factory one quarter of a mile west of the former Seaboard Oil and Guano Company. They operated for about 10 years before they moved their operations to Chincoteague. The waters in Toms Cove became too shallow for the larger ships to be able to dock. (Quillen.)

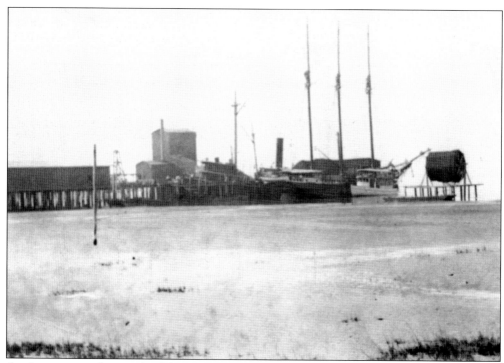

A schooner is tied up at the fish factory in the photograph above. Schooners were ships with two or more masts that carried cargo between ports. After the menhaden were processed, the barrels of oil and the bags of fertilizer would be loaded and shipped to customers in the South or the North. (Jones family.)

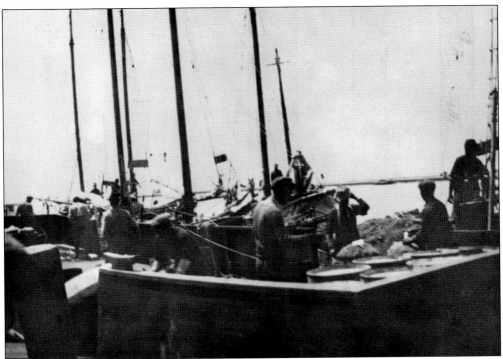

Menhaden were found in large schools off the coast. They were caught in large nets and brought to the fish factory. The fish were unloaded from ships tied up at the dock. They were then taken to a conveyor that carried them up a platform. From there, they were shoveled into the kettles to be cooked. This process often happened at night. (Jones family.)

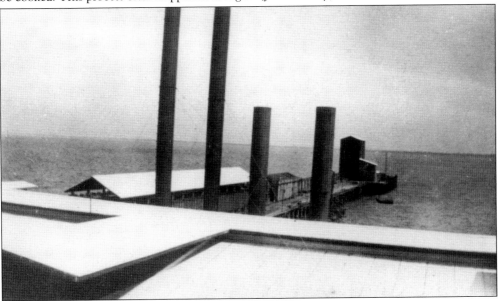

The fish factory stacks were visible from the seaside and provided mariners with an additional landmark besides the lighthouse by which to navigate. The ships carrying menhaden would sail into Toms Cove to the docks. When too much sand silted into the cove, the water became too shallow for the larger ships to dock. (Quillen.)

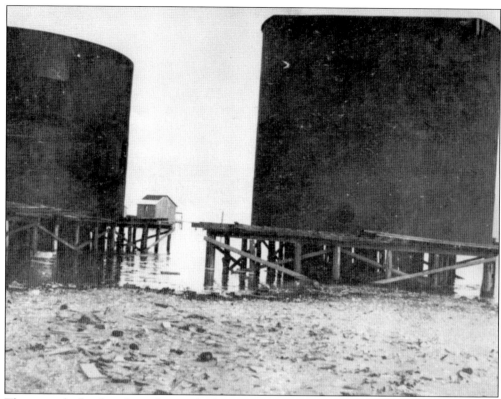

These are the kettles where the menhaden were cooked. The fish was then pressed to remove the oil, which was put into barrels to be shipped. The scraps, which included the bones, skin, and meat, were sent to a drying shed. When processed, the scraps would be put in 100-pound bags ready for shipment. Some of the oil was used as lighthouse fuel; however, by this time, the Assateague Lighthouse used kerosene. Oil was also used in paints and dietary supplements, while the dried remains were used as fertilizer. It was advertised as the best fertilizer for growing anything on the Eastern Shore. (Jones family.)

Six

PONIES

Pony penning is a tradition with a long history. As early as 1835, a letter to the editor in the *Farmer's Register* mentioned pony penning. How the ponies got to the barrier islands is a subject of debate. Some believe they came from when settlers left their ponies on the barrier islands to graze to avoid taxes, while others go with the legend of the shipwrecked *La Galga* that occurred in 1750. John Amrhein Jr. spent years researching the *La Galga*, both here and in Spain, and feels he has documented proof of their origin.

Since the arrival of the ponies, they have undergone several changes. The earliest ponies were black, bay, or sorrel in color. Other breeds have been introduced, including Arabian and Shetland ponies. The paints that are common today did not evolve until later.

Pony penning was a two-day event held one day on Assateague and one day on Chincoteague. At first, only men were involved, as the event involved drinking and betting on races. After 1922, when Samuel B. Field established his stock farm, the villagers could no longer hold this event on Assateague.

Chincoteague's downtown fire in 1922 led to the establishment of the Chincoteague Fire Department and the need to raise money for equipment. In 1924, the fire department combined both herds and began the annual pony swim from Assateague. The firemen also purchased ponies from privately owned herds on nearby islands. Since that time, the Chincoteague Fire Company has owned the herd now grazing on Assateague.

In the beginning, pony penning on Chincoteague was a small event with only 15,000 in attendance compared to the 50,000 plus who attend today. Prices were a lot less, too. In 1925, a colt brought about $75 and a filly, $90. Today, the Chincoteague Fire Company has received more than $10,000 for a foal.

When the US Fish and Wildlife Service bought the property on Assateague, an agreement was made between the Chincoteague Fire Company and Chincoteague National Wildlife Refuge to allow them to graze 150 adult ponies on the refuge by permit.

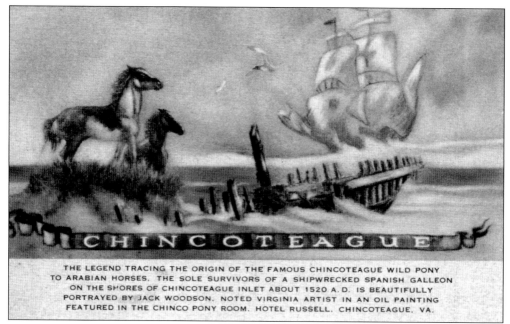

A mural by Jack Woodson on the wall of the Hotel Russell told a legend of the ponies. It stated that they came ashore from a 1520 shipwreck off the coast of Assateague. This is but one of the many legends attempting to explain the origin of the ponies. (Robert E Wilson.)

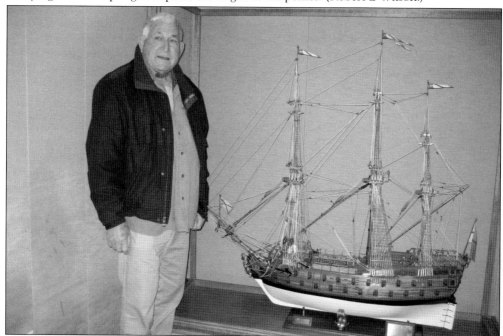

Another story relating to the origin of the Chincoteague ponies claims the Spanish ship *La Galga* was carrying ponies when it was shipwrecked off the coast of Assateague in 1750. John Amrhein Jr. researched the *La Galga* and wrote the book *The Hidden Galleon*, documenting his findings. Bill Bane of Wachapregue built this model of the *La Galga* on display in the Bateman Visitor Center. (MJC.)

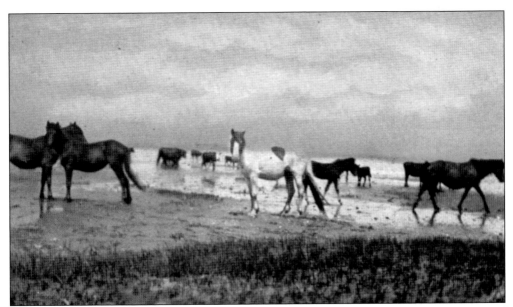

At the edge of the surf are some of the ponies as well as some cattle. The cattle were part of Field's stock farm. The original ponies were dark-colored blacks, bays, and sorrels. Breeding with several other breeds has resulted in paints and palominos as well as the darker colors. (Robert E Wilson.)

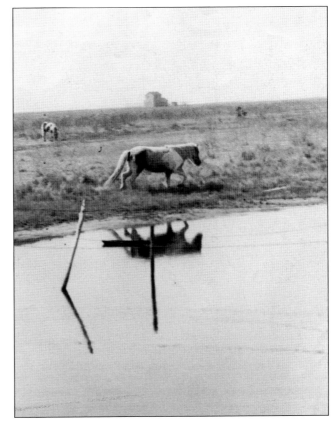

In the photograph at right, ponies graze near one of the cottages at Toms Cove. Today, the ponies are divided into two herds. There are about 100 ponies in the northern herd and 50 ponies in the southern herd. The ponies then divide themselves into bands. Each band has a stallion and 10 to 15 mares. (Quillen.)

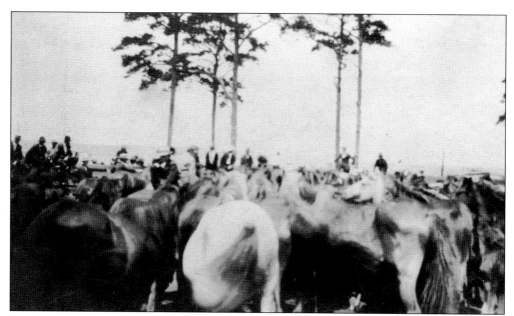

Pony penning was originally held on both Assateague and Chincoteague. It was a time when men got together to round up and brand the ponies to designate ownership. They also competed in races, which were complimented with gambling and drinking. Women were not allowed to participate. (Quillen.)

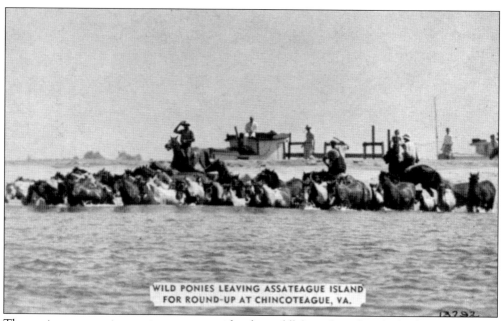

WILD PONIES LEAVING ASSATEAGUE ISLAND
FOR ROUND-UP AT CHINCOTEAGUE, VA.

The ponies, a nonnative species, compete with other wildlife on the refuge for food. An agreement between Chincoteague National Wildlife Refuge (CNWR) and the Chincoteague Fire Department allow 150 adult ponies to graze on the refuge. Pony penning and the auctioning of the foals not only raises money for the fire department, but retains the size of the herd. (Robert E. Wilson.)

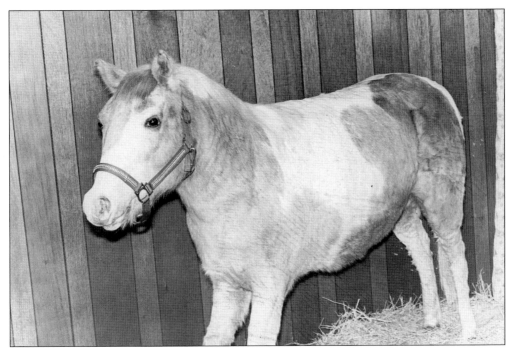

Misty of Chincoteague, a children's book written by Marguerite Henry and published in 1947, told the story of a Chincoteague pony and the children who owned her. Henry purchased Misty from Clarence Beebe. She returned her to Chincoteague in 1957 to be bred. Misty's foals became the subjects of a series of books. (ESNA.)

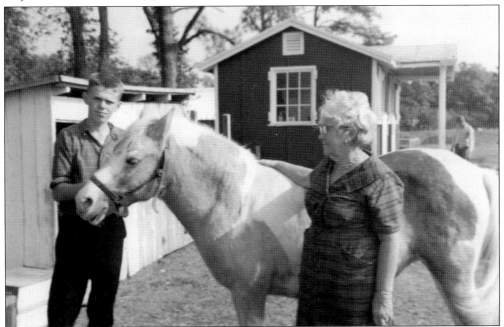

Denny Beebe is posing with Misty and an unidentified woman at the Beebe Ranch where Misty was taken to be bred. Her colt, Stormy, born during the 1962 flood, was the subject of another of Henry's books. A statue of Misty is in the downtown Robert Reed Park. (Quillen.)

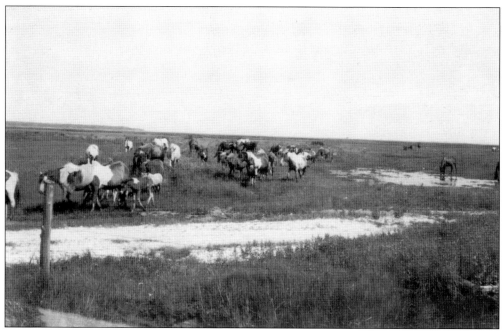

Ponies are roaming freely in one of the two compounds where they are separated from sensitive areas of the refuge. The ponies are divided into two herds—the northern herd roams the area along the service road to the north, while the southern herd is located off Beach Road on the right. They can be seen from the Woodland Trail. (Donna Mason.)

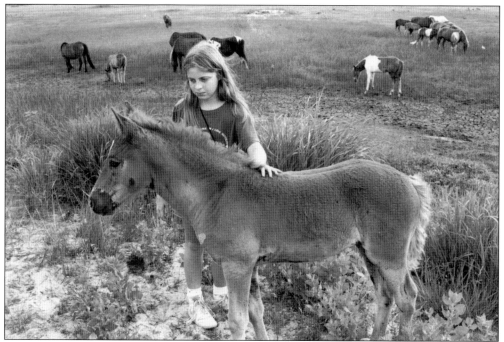

Ponies roamed the refuge at will at one time, and tourists could walk up and pet them. This became a problem when visitors did not respect them as wild animals. Visitors fed them snack foods, drove too close, and approached them without caution, especially young children. (ESNA.)

Seven

PROTECTING THE SHORE

The Assateague Beach Life-Saving Station was commissioned in 1875 on what was then the southern shore of an open bay at the south end of the island. The station consisted of a one-and-a-half-story station, a cookhouse, a barn, a generator shack, and other outbuildings. There were some bungalows in the area, including one owned by the Sharretts family.

The station was located in the area of the Woodland Trail. All that remains today is a portion of the old cistern that lies in the woods north of the entrance to the trail.

A surfman would be on duty from August 1 until June and then would be home on vacation. Some of the surfmen owned homes on Chincoteague, while some stayed in Assateague Village. Crews practiced using equipment daily, so that they were prepared when their skills were needed. Each day of the week was used to practice a different skill. Some of the more difficult operations were practiced more than one day a week.

This station participated in 15 major shipwrecks with only two resulting in the loss of life. Only four lives were lost. The most famous was probably the wreck of the presidential yacht *Despatch*. All aboard were saved, including several pets. Only the uninvited black cat lost its life.

In 1918, German U-boats cruised the waters near Assateague. In May of that year, *U-151* destroyed three ships—the *Hattie Dunn*, *Hauppauge*, and *Edna*—and took their crews hostage. They were released after a week. Fortunately, there were no casualties and the U-boat threat ended that summer.

In 1915, the Assateague Beach Life-Saving Service merged with the Revenue Cutter Service and became the US Coast Guard.

The growth of the lower shore of Assateague left the old Assateague Beach Life-Saving Station too far from the open waters of the Atlantic Ocean. In 1922, a new station house and boathouse were built close to Fishing Point. This station operated until all branches were moved to Chincoteague and the buildings were turned over to the National Park Service in 1967.

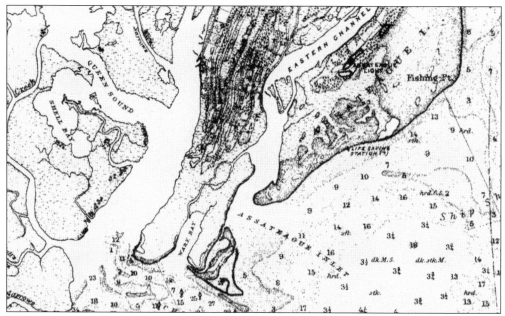

This 1880 nautical map shows that there is no lower shore or "hook." The Life-Saving Station was located directly on the shore. Fishing Point is located almost directly east of the lighthouse. As the island grew to the south and west, the terminal end became Fishing Point.

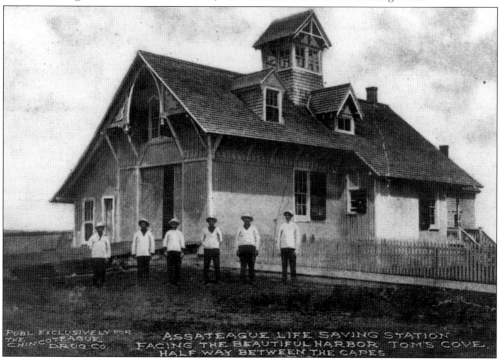

The Assateague Beach Life-Saving Station on Assateague Island was commissioned in 1875. It was a one-and-a-half-story frame building with a cookhouse, shed annex, toolshed, and barn. All that remains today is a piece of the cistern. The men standing outside the station house in dress whites are unidentified. (CNWR.)

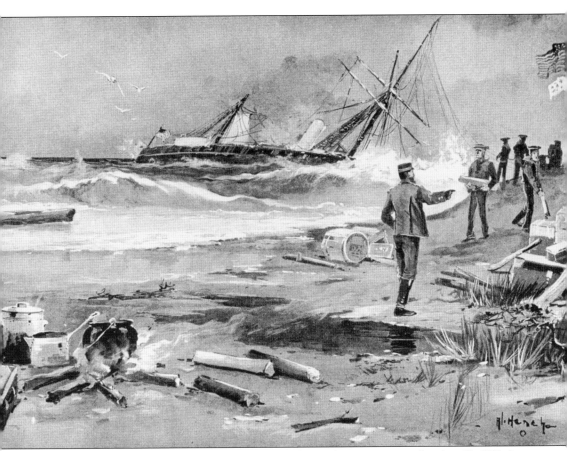

The presidential yacht *Despatch* was wrecked off the shore of Assateague on October 10, 1891. It was traveling from Brooklyn, New York, to Washington, DC, to take on Pres. Benjamin Harrison. On the night of October 9, with the wind blowing from the northeast, heavy surf, and the sky leaden with fog, Lieutenant Cowles mistook the Assateague Lighthouse for the *Winter Quarter* lightship. The mistake occurred because in the fog, the white light of Assateague appeared as an orange tint, almost red. The *Winter Quarter* carried a red light. Striking the shoals off Assateague at 3:00 a.m., there was no saving the ship. Capt. James T. Tracy and his crew from the Assateague Beach Life-Saving Station saved all 79 men as well as two collie dogs and a Maltese cat. The only casualty was a black cat that the superstitious crew saw as an evil omen. The wreck occurred three miles from the end of the island, about 75 yards offshore. Wreckage was spread over three miles of the shoreline. (The Mariners' Museum, Newport News, Virginia.)

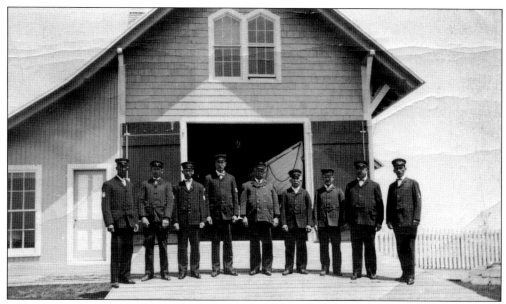

The crewmembers standing outside the Assateague Beach Life-Saving Station house in 1905 are, from left to right, Granville Hogg, Bert Bowden, Lee Mason, John Taylor, Capt. Joe Fedderman, John Kambarn, Joshua Hudson, John Snead, and Selby Andrews. They represent a full complement of men. Captain Fedderman served at Pope Island before coming to Assateague. (OCGS.)

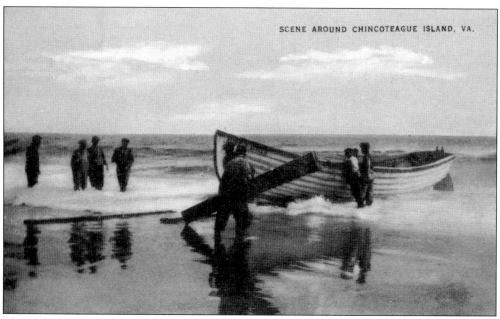

The surfmen practiced daily with their equipment to sharpen their skills and understand their individual responsibilities during a rescue. Training on some apparatus, such as the breeches buoy, was conducted more than once a week because of its importance and difficulty in handling. (Robert E. Wilson.)

The growth of Assateague Island can be recognized in this map. In less than 40 years, the island grew several miles longer. It shows why the location of the Coast Guard Station was moved to the other side of Toms Cove near the end of Fishing Point— it provided better access to the ocean.

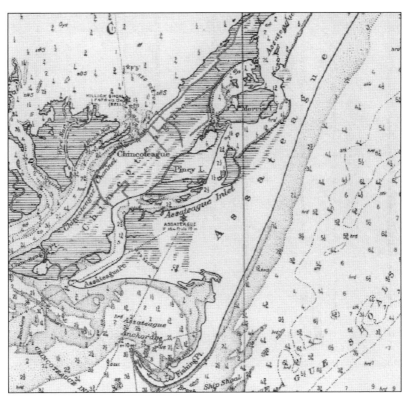

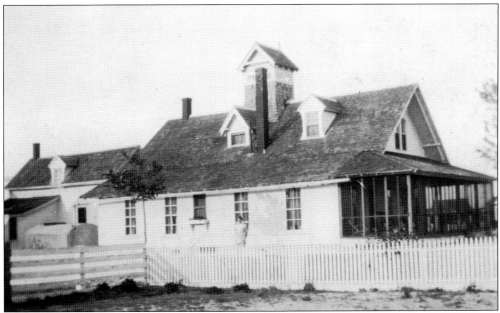

The original Assateague Beach Life-Saving Station is seen above as a dwelling. Samuel B. Field remodeled the original station after he traded properties with the government. In the early 1920s, he gave them property on Fishing Point for a new station closer to the surf. He then fenced in his property, hired an overseer, and established a stock farm raising cattle and ponies. Field was accused of denying the people of the village access to their work. (CNWR.)

Assateague Island's shoreline grew, forming Toms Cove and the "hook," leaving the original Assateague Beach Life-Saving Station far from the open waters of the Atlantic. The Coast Guard built a new station house on Fishing Point, less than three miles southwest of the Assateague Lighthouse. In 1967, they moved their operations to Chincoteague and turned the building over to the National Park Service. (Gretchen Knapp.)

The Assateague Beach Coast Guard Station boathouse, built 1938 to 1939, replaced a smaller 1922 boathouse. It was located 150 yards west of the former site of the Chincoteague Fish Oil and Guano Company and north of the 1922 station house. It contains two rooms, an entryway, and three bays for maintenance and storage of boats. The boathouse doorways lead to a wooden-planked launch way with steel runners. (USCG.)

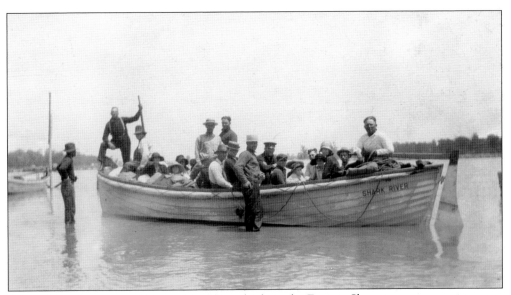

Coast Guard boats and personnel were brought from the Eastern Shore to participate in rescue operations during the Mississippi River flood of 1927. Capt. Ernest Pointer is shown with a boat full of people. Captain Pointer served at Assateague Beach, Wallops Island, and Chincoteague as well as at several other stations across the country. (CNWR.)

During the mid-1930s, members of the Assateague Beach Coast Guard held a water carnival at the same time as the pony penning event. They competed in rowing races in Chincoteague Channel as well as capsizing boats and righting them in less than five minutes. Teams from Assateague Beach, Wallops Island, and Lewis, Delaware, participated in the activities. (OCGS.)

Coast Guard personnel from Assateague Beach, Wallops Island, and other Coast Guard stations in the surrounding area were called upon to provide assistance in the devastating Mississippi River basin flood of 1927. Coast Guardsmen and Coast Guard boats were taken to Franklin City, and then loaded on a train to be sent to Missouri. Pictured are some of the 647 Coast Guard members and 128 vessels used to rescue 43,853 persons from dangerous positions to places of safety. They

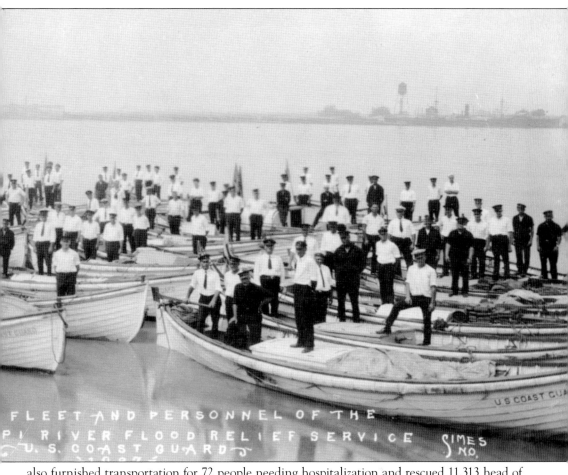

FLEET AND PERSONNEL OF THE PI RIVER FLOOD RELIEF SERVICE U. S. COAST GUARD SIMES NO.

also furnished transportation for 72 people needing hospitalization and rescued 11,313 head of livestock. The scope of the operations actually surpassed the number of persons that the Coast Guard rescued during the Hurricane Katrina relief. Local Coast Guardsmen participating included Wilmer Clark, Jesse McGee, James Peterson, and Ernest Pointer. (Roy Jones.)

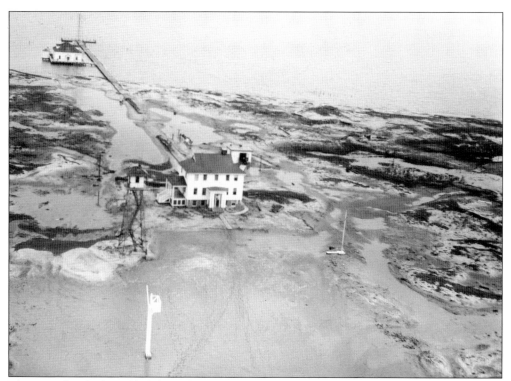

The 1962 flood, also called the Ash Wednesday Flood, caused a lot of destruction in the area. On Assateague, there was a strong overwash. The crew from the Assateague Beach Coast Guard Station was evacuated by helicopter to NASA. They assisted victims on Chincoteague before they returned to the station on Assateague. (USCG.)

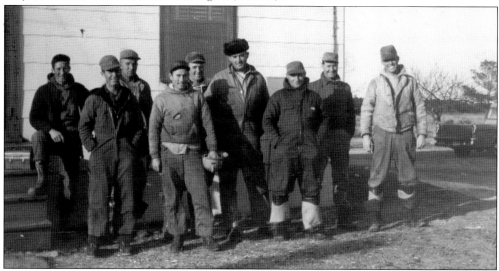

The 1962 storm flooded and destroyed the dunes on Assateague Beach. Men from Chincoteague were hired on a temporary basis to rebuild dunes and restore the damaged beach. The crew included, from left to right, George E. Bowden, William L. "Bill" Williams Jr., John L. Clark, Alexander "Joe" Justice, Carlton "Cork" McGee, Bernard Hurdle Jr., Darrell Merritt, Stanley E. Turlington, and Earl D. "Early Bird" Bowden. (CNWR.)

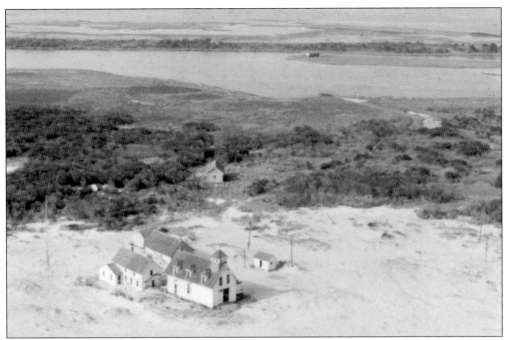

The Pope Island Life-Saving Station was commissioned in 1878, and at the time, it was thought to be in Maryland. Although Pope Island is in Maryland, a later survey revealed the Pope Island Life-Saving Station was actually in Virginia. It was known as a beach station as opposed to an inlet station. (CNWR.)

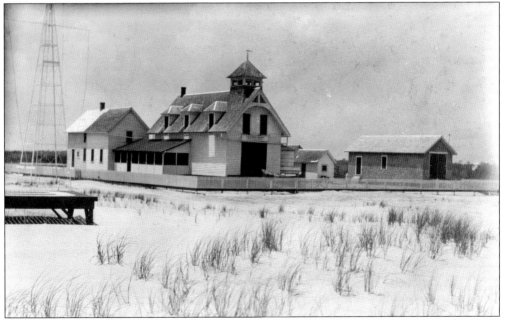

The role of the surfmen was to prevent shipwrecks along the shore and to rescue and provide assistance to those on shipwrecks. The unofficial motto of the US Life-Saving Service was, "You have to go out, but you don't have to come back." This station responded to four major shipwrecks. (OCGS.)

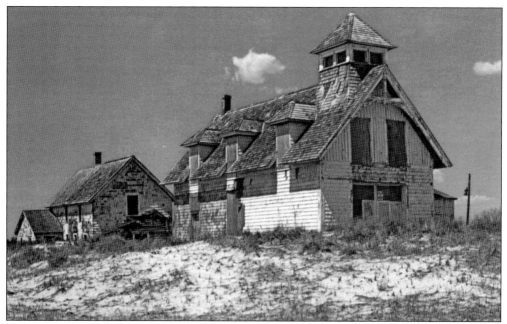

The Pope Island station was abandoned in 1953 and deteriorated rapidly after the March 1962 flood. Then, in 1970, the main building and two small outbuildings were destroyed by fire. Vandalism was suspected. The boathouse was spared, moved, and restored. In 1981, fire struck again, burning the coal house, the only remaining structure. (Robert E. Wilson.)

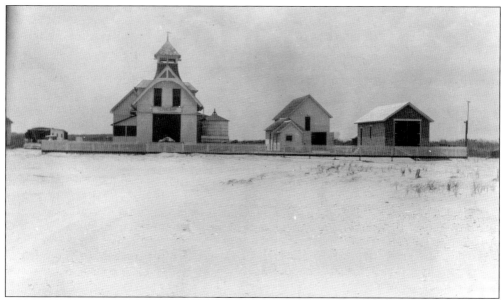

The Pope Island Boathouse was removed to the site of the North Beach Life-Saving Station in Maryland in 1974. It was remodeled and is now a museum. The other life-saving station located on Assateague in Maryland was Green Run. It was situated about eight miles south of North Beach. (Robert E. Wilson.)

Eight

FEDERAL LANDS

Today, Assateague Island, Virginia, belongs to the people. It is owned and managed by two agencies of the Department of the Interior. The US Fish and Wildlife Service purchased most of the property on the Virginia end of Assateague beginning in 1943. The Assateague Island National Seashore was established as part of the National Park Service in 1965.

Chincoteague National Wildlife Refuge (CNWR) is named "Chincoteague" rather than "Assateague" because at the time of its founding, the custom of the service was to name refuges after the closest post office. Located in the Atlantic Flyway, its primary purpose was for the conservation of migratory birds, mainly the greater snow goose as well as native plants and wildlife. Since CNWR was established, conservation of threatened and endangered species and providing recreational wildlife activities has been added to its purpose. These recreational activities centered on wildlife include hunting, fishing, wildlife observation, photography, environmental education, and interpretation.

Assateague Island National Seashore, managed by the National Park Service, was established in 1965 to provide for recreational use and enjoyment consistent with the maintenance and perpetuation of the seashore's natural communities.

The park service purchased the assets of the Chincoteague-Assateague Bridge and Beach Authority. Their biggest problem was the old Thunder Bridge. It was a 50-year-old bridge with serious rust problems. The National Park Service, along with the Federal Highway Administration, planned for a replacement span of reinforced concrete completed in December 1979.

The remodeled Roundup Restaurant became the Toms Cove Visitor Center, which offers interpretive displays, aquaria, maps and publications, a sales outlet, and offices.

The National Park Service manages the recreational beach as well as maintaining the bridge from Chincoteague. Because of the storms that occur yearly, reconstruction of the beach road and parking lots is an annual job. They are aware that all their works are temporary and that it is inevitable that the inherent forces of nature will alter Assateague Island.

Ding Darling was a well-known Pulitzer Prize–winning cartoonist who conceived the idea of the Migratory Bird Hunting and Conservation Stamp commonly known as the "duck stamp." The purpose of the stamp is to buy and preserve wetlands. He designed the first stamp in 1934, depicting a pair of mallards landing. Pres. Franklin Delano Roosevelt appointed him the head of the US Biological Survey, the predecessor of the US Federal Wildlife Service. In 1936, he founded the National Wildlife Federation. It was due to monies acquired through the purchase of duck stamps that the Chincoteague National Wildlife Refuge was purchased in 1943 during World War II. The price was $75,000 for 8,808 acres, including most of the Virginia property on Assateague. The federal government already owned the Assateague Lighthouse and the US Coast Guard properties. A small amount of property was privately owned. (CNWR.)

After years of planning and scores of obstacles, the Chincoteague-Assateague Bridge and Beach Authority finally completed the long-awaited bridge to Assateague Island in 1962. The bridge, originally built in 1915, spanned the Mullica River about eight miles from Atlantic City, New Jersey. The $500,000 project planned by the authority also included a restaurant, bathhouses, concession booths, and parking lots to be built as growth permitted. (Quillen.)

When Wyle Maddox first came to Chincoteague, he opened a blacksmith shop on Main Street. Then, in 1946, he became a building contractor and raised chickens. Working with the Chincoteague-Assateague Bridge and Beach Authority, he purchased, relocated, and installed the first bridge to Assateague Island. Maddox also owned a tug, barges, and land on Piney Island on little Oyster Bay. He built the road that bears his name, Maddox Boulevard. (Roxane Stevens.)

The bridge to Assateague opened the Chincoteague National Wildlife Refuge and the ocean beach to the public. This was the beginning of tourism as an industry on Chincoteague. The four-span steel truss bridge with its wooden surface was fondly referred to as the Thunder Bridge because of the noise made while crossing it. (ESNA.)

The National Park Service purchased all the Chincoteague-Assateague Bridge and Beach Authority's assets in 1966 for $600,000. The old bridge served its purpose, providing access to Assateague. However, serious rusting of the trusses persuaded the National Park Service to replace it for the safety of visitors to the island. The new bridge opened in December 1979. (ESNA.)

The original Chincoteague National Wildlife Refuge Administration Building was located on Beach Road. Behind it were two other buildings: one for staff and another that contained an auditorium where evening programs were held. These were replaced when the Herbert H. Bateman Educational and Administrative Center was built in 2003. Maintenance had their own facilities in another area. (CNWR.)

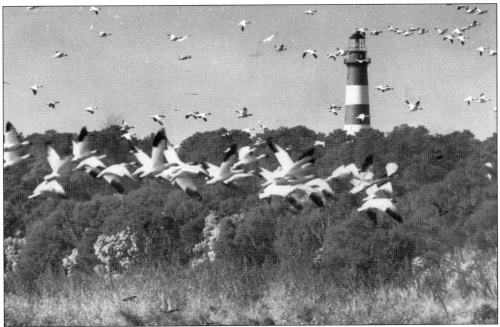

Each wildlife refuge is established with a purpose. At the time of its establishment, the greater snow goose population was seriously depleted. Today, with the success of its protection, thousands of snow geese visit Assateague yearly. Early in the day, they can be seen taking to the sky to visit nearby farmers' fields and then they return in the evening. (CNWR.)

Here, sika elk are seen taking food from a Delmarva Peninsula fox squirrel feeder. The sika is a nonnative species from the Orient. Many call them deer because they sport spots and look like fawns. Differences to note are their powder puff–type rear and antlers that slant backwards. (CNWR.)

In the 1920s, the Boy Scouts in Ocean City obtained some sika elk and showed them off to raise money. At the end of the season, they released them on Assateague. The sika survived well and multiplied. On Assateague, they had no predators, disease, or parasites. In the Virginia area, there are about 750 to 900 sika elks. To manage the population, the CNWR conducts a controlled hunt yearly. (Robert E. Wilson.)

The Delmarva Peninsula fox squirrel differs from the common gray squirrel in that they are larger, about two to three pounds each, and timid. They forage on the ground for their food. Their usual nest is in holes in hardwood trees. The lack of hardwoods on Assateague requires squirrel-nesting boxes attached to trees. (Robert E. Wilson.)

The clearing of land for farms and houses destroyed much of the Delmarva Peninsula fox squirrel's native habitat, decreasing their numbers drastically. In 1968, thirty-eight Delmarva Peninsula fox squirrels were introduced to CNWR to start a breeding program to increase their numbers. The program has been successful with several squirrels being reintroduced to the Nature Conservancy in Northampton County. (CNWR.)

One popular activity on the beach is kite flying. Colorful kites of all kinds, from the very simple to the complex, can be seen soaring in the sky on days when the wind is right. It is an event participated in by all ages, including the very young. (ESNA.)

Chincoteague National Wildlife Refuge has a collection of guns, boats, decoys, and other artifacts that were found or used in the area. There are some on permanent display, while some are displayed only on special occasions. They are kept in a climate-controlled archive room when not exhibited for protection. (CNWR.)

Bob Cherrix and Noah Williams of maintenance are shown helping to capture brant for banding. The brant is a small saltwater goose that looks similar to a Canada goose. It breeds in the arctic tundra but spends its winters along the coast. Banding provides information about the breed's migration, population, and nesting. (CNWR.)

Dennis "Denny" Holland, refuge manager, holds a peregrine for banding. Biologist Dr. Scott Ward and his associates trapped and banded peregrine falcons on Assateague for over 13 years. Peregrines became endangered as a result of DDT pesticides. One of their objectives was to see if the ban on DDT had an effect, and they did record an increase in population over the years. Today, some of the falcons are radio marked and traced by satellite. (CNWR.)

Tom Reed was a local market hunter before there was a season and limits on hunters. He is displaying one of his hollow decoys used to hide illegal ducks from the game warden. His knowledge of Assateague Island and wildlife was an asset to the Chincoteague National Wildlife Refuge. A bench dedicated to Reed on the Wildlife Loop reads "PDH" after his name. It stands for "pretty darn handy." (CNWR.)

After his mother's death, Miles Hancock's father brought his four children from Delaware to Assateague and Chincoteague to find them homes. Miles, only six years old, lived with his foster parents, Laura and Asbury Williams. He was a skilled hunter and became an "outlaw gunner" when bag limits were established. He later became a successful guide. Hancock began carving hunting decoys in 1929 and carved decorative decoys into his late 80s. (CNWR.)

The first Wildlife Safari began when Lee Savage and "Mac" McCoy purchased a Jeep with a 20-passenger white bus-like trailer. A contract with CNWR allowed them to take visitors up the service road to the northern end of the island in Virginia and other areas. Savage would talk to the passengers about the refuge. In August 1972, a new vehicle, a truck with a 44-passenger trailer, replaced the original. (Donna Mason.)

Biking is a year-round activity for all ages on the refuge. The Wildlife Loop and the Woodland Trail are two areas that provide miles of biking and hiking free from traffic. It provides a quiet way to observe nature or an alternate way to access the beach. (ESNA.)

Refuge manager Dennis Holland presented an achievement award to Charles Holbrook for helping establish a refuge cooperating organization. Founded in 1986, the Chincoteague Natural History Association's purpose was to raise money for educational programs at the refuge. They began with a sales outlet in the old visitor center and now operate lighthouse tours and conduct the Wildlife Safari tour on an air-conditioned bus. (CNWR.)

The old refuge visitor center was opened to the public in May 1973. It served as a reception area and education and information center. Reservations were available here for concession-operated tours. After the formation of the Chincoteague Natural History Association, a sales area was added for refuge-related items. (ESNA.)

Volunteer Joan Moschitta, park ranger Bertie McNally, and deputy refuge manager Robert Wilson pose in the old visitor contact station and sales outlet. Here, refuge guests could check out activities, ask questions, see movies, explore the touch table, view displays, and buy souvenirs. There was a lot to do in a very small space. (CNWR.)

The old visitor center's touch table had a number of articles, including shells, egg cases, animal skins, and other objects found on the refuge. Children could pick up and examine all the objects and ask questions of the volunteers or interns. The aquarium contained species found in the local waters. (CNWR.)

In the image above, a wildlife biology technician relocates loggerhead sea turtle eggs. From 1969 to 1979, loggerhead eggs were translocated from North Carolina to expand their breeding area. The eggs were buried and protected with predator exclosures. Hatchlings were released into waters surrounding CNWR. Recently, the nesting activity of loggerheads on Assateague has risen considerably. (ESNA.)

Several times a year, volunteers of all ages help the CNWR and the National Park Service scour the beach for debris. They find all types of objects, from things left behind by thoughtless visitors to objects unearthed by storms or that have washed ashore. The trash is removed and disposed of, leaving the beach pristine. (ESNA.)

Herbert H. Bateman Educational and Administrative Center was opened in 2003 during the 100th anniversary year of the National Fish and Wildlife System. Pres. Theodore Roosevelt saw a need to provide sanctuary for wildlife for future generations to enjoy by establishing the system in 1903. The Bateman Center is an example of green architecture, which aims to minimize negative impacts on the environment by conserving and using natural resources efficiently. Some of the environmentally friendly products used include recycled rubber flooring and recycled content carpet. The bamboo and cork flooring are made from renewable resources. Featured in the building are exhibits depicting all four ecological areas of the refuge, a visitor information center, gift shop, auditorium, classroom/lab, and an archival storage area. An eagle cam allows visitors to observe an eagle's nest from when eggs are laid until the young eaglets are fledged. (CNWR.)

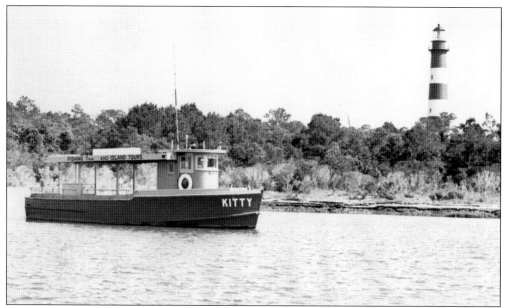

In 1968, Donald Leonard and George Taylor purchased a boat from New Jersey to conduct fishing tours and narrated tours in cooperation with the CNWR. Refuge visitors purchased tickets for the 7:00 a.m. to 2:00 p.m. fishing tour or the narrated sunset tour. They changed the name of the boat to the *Osprey*, which was more in keeping with the refuge. (CNWR.)

People continued to enjoy the narrated tours for close to 30 years. Interpreters Donna Leonard and Jenny Somers related the history of the island and the people and pointed out clam beds and oyster rocks while explaining the work of the waterman. Fishing trips were discontinued at an earlier date. (ESNA.)

This geodesic dome was located in the traffic circle on Maddox Boulevard in 1966 as an information center for the National Park Service on Assateague. In 1968, a larger dome at the beach assumed its function. When it was no longer used, it became the construction office for the building of the new bridge. The property was turned over to Accomack County and is now the property of the Chincoteague Chamber of Commerce. (CNWR.)

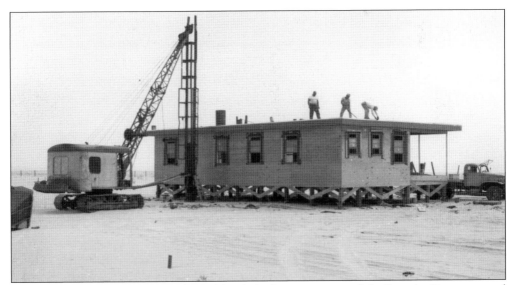

The Chincoteague-Assateague Bridge and Beach Authority constructed the Roundup Restaurant and bathhouses in 1964 for the benefit of visitors to the beach. It was located in parking lot no. 1 before it was bought by the park service, remodeled into their visitor center, and moved. (CNWR.)

The Roundup Restaurant was a popular a place to visit. It sold food, drinks, and snacks as well as souvenirs and surf fishing supplies. There are no longer any concessions on the beach. Visitors must bring everything they need for themselves and their family to enjoy their time on the sand. (CNWR.)

In the photograph above, visitors to the refuge enjoy trying their hand at catching crabs. One popular area is at Swans Cove as well as near the bridge at the entrance to the refuge. Armed with chicken necks, string, a net, and something to put their catch in, crabbers hope to get enough for dinner. (Robert E. Wilson.)

The National Park Service Visitor Center at Toms Cove has been moved three times due to the erosion of the beach. It originally was built as the Roundup Restaurant. The National Park Service bought the concession and remodeled the building in 1977 for their headquarters and visitor services in Virginia. It is now on pilings overlooking the marsh. Hopefully, it is out of harms way. (ESNA.)

A park ranger is standing at an interpretive wayside sign providing information about Toms Cove. Toms Cove is known for the clams and oysters that are harvested there. The salinity of the water and the pure white sands on the bottom give them an exceptional taste and a clean, white look. Visitors are allowed access to areas of Toms Cove to try their hand at clamming. (ESNA.)

121

Armed with everything from fishing poles to coolers, umbrellas, boogie boards, suntan lotion, and chairs, families arrive early to stake their claim to their own sandy piece of the beach. There are no concessions on the beach, so one must be prepared to bring everything needed for a day of fun. (ESNA.)

Surf fishing at the beach is a popular sport. Usually, fisherman can be found at either end of the bathing beach area or in the off-road vehicle area, except during the piping plover season. Some of the varieties of fish caught are spot, rockfish, flounder, kingfish, croaker, and shark. (ESNA.)

In a secluded area north of the public beach was a nude beach. It became very popular until it was featured in an issue of *Playboy Magazine*. A group of female churchgoers on Chincoteague became aware of its existence and successfully petitioned Accomack County to pass an ordinance prohibiting nudity. (CNWR.)

A group of 250 naturalists demonstrated in protest against the anti-nudity ordinance on National Nude Weekend in July 1984. One disgruntled protestor added his own comment to the sign near the entrance to the refuge. Signs informing visitors of restrictions on the refuge still feature "no nudity." (CNWR.)

During the summertime, the parking lots fill up early with families and individuals who come to the beach to swim, get a tan, or just enjoy the salt air. Kids enjoy their boogie boards, and serious surfers dressed in wet suits are to be found when the surf's up. The clean, white sand is hard to beat. (ESNA.)

There are no concessions on the beach so visitors must provide their own; however, eating it can present a problem. Seagulls will quickly join in, hoping for a scrap. More than one person has lost a sandwich or other tidbit by holding their hand to the side. (ESNA.)

Pictured above and below are two storms that caused extensive damage to the beach in 1982 and 1991. Notice the lack of dunes in the second picture and how the ocean is washing over the parking lot. Storms on the beach usually occur between late October and March and are sometimes quite severe. They cause widespread damage to the beach, washing over low areas, flooding parking lots, and eroding sand. These storms are called nor'easters because of the direction of the wind. They are more damaging than hurricanes. Hurricanes last several hours, but a nor'easter can last for several days. (NPS.)

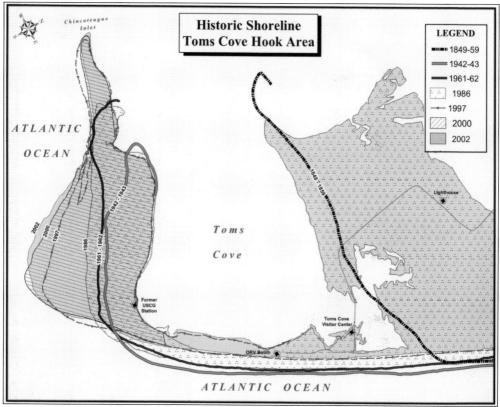

Since 1849, the shoreline of Assateague has changed dramatically. The entire length of the island has been extended about five miles by accretion. Toms Cove, which was also called Assateague Anchorage, was formed by this growth. Changes occur yearly due to nor'easters and the effect of currents along the shore. (NPS.)

An aerial view of the "hook" shows how the action of the waves has shaped the island. This is a limited access area. From March 15 until September or whenever all the piping plover have fledged, this area is closed. At other times of the year, it is open for over the sand vehicles (OSV). (Robert E. Wilson.)

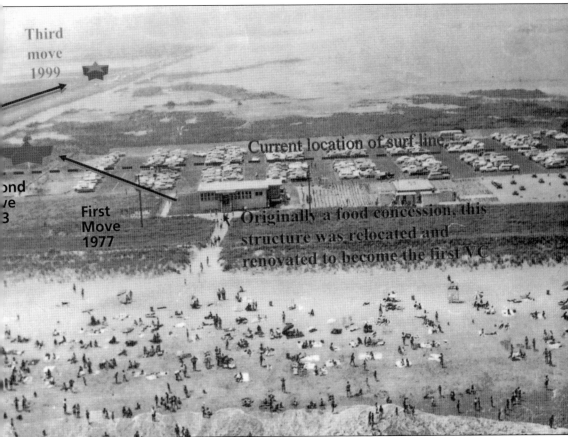

Third
move
1999

Current location of surf line

ond
ve
3

First
Move
1977

Originally a food concession, this
structure was relocated and
renovated to become the first VC

This aerial view shows how the beach has changed since the 1960s. The building in the center was originally a food concession building that became the Park Service Visitors Center after the Assateague National Seashore was established. In 1977, it was moved to its second location further from the encroaching sea. The shore then encountered a number of damaging storms during the 1980s and 1990s that required two additional moves in order for it to be protected from the sea. The bathhouses, the walkways over the dunes, and even the parking lots have been overrun by the ocean waters. What was once sandy beach is now a part of the ocean. Additionally, the marsh on the bay side is being covered with sand. This is a perfect example of the dynamics of a barrier island. (NPS.)

DISCOVER THOUSANDS OF LOCAL HISTORY BOOKS FEATURING MILLIONS OF VINTAGE IMAGES

Arcadia Publishing, the leading local history publisher in the United States, is committed to making history accessible and meaningful through publishing books that celebrate and preserve the heritage of America's people and places.

Find more books like this at
www.arcadiapublishing.com

Search for your hometown history, your old stomping grounds, and even your favorite sports team.

Consistent with our mission to preserve history on a local level, this book was printed in South Carolina on American-made paper and manufactured entirely in the United States. Products carrying the accredited Forest Stewardship Council (FSC) label are printed on 100 percent FSC-certified paper.

MADE IN THE
USA